COLLIER BOOKS | ART NEWS SERIES

*Each of the anthologies in the series explores
the range of our history from specific points of
view of major importance, to all the arts.*

ACADEMIC ART

AVANT-GARDE ART

THE GRAND ECCENTRICS

LIGHT IN ART

ART AND SEXUAL POLITICS

Art and
Sexual Politics

WOMEN'S LIBERATION,

WOMEN ARTISTS,

AND ART HISTORY

EDITED BY

Thomas B. Hess AND Elizabeth C. Baker

ART NEWS SERIES 146251

COLLIER BOOKS
A Division of Macmillan Publishing Co., Inc.
NEW YORK

COLLIER MACMILLAN PUBLISHERS
LONDON

Macmillan Publishing Co., Inc.
866 Third Avenue, New York, N.Y. 10022
Collier Macmillan Canada, Ltd.

The essays appearing in this Collier Books Edition
originally appeared in *Art News*, Volume 69, Number 9,
and are reprinted here in revised form.

Art and Sexual Politics is also published in a hardcover
edition by Macmillan Publishing Co., Inc.

Library of Congress Catalog Card Number: 72-85182

First Collier Books Edition 1973
12 11 10 9 8 7 6 5
Printed in the United States of America

Contents

LIST OF ILLUSTRATIONS vii

WHY HAVE THERE BEEN NO GREAT WOMEN ARTISTS?
 by Linda Nochlin 1

GREAT WOMEN ARTISTS, *by Thomas B. Hess* 44

WHY HAVE THERE BEEN NO GREAT WOMEN ARTISTS?
 TEN REPLIES 55

 Dialogue, *by Elaine de Kooning with Rosalyn Drexler* 56

 The Hermaphrodite, *by Bridget Riley* 82

 Do Your Work, *by Louise Nevelson* 84

 Women without Pathos, *by Eleanor Antin* 86

 The Double-Bind, *by Suzi Gablik* 88

 Healthy Self-Love, *by Sylvia Stone* 90

 Moving Out, Moving Up, *by Marjorie Strider* 93

 Social Conditions Can Change, *by Lynda Benglis* 96

 Artists Transgress All Boundaries, *by Rosemarie Castoro* 98

SEXUAL ART-POLITICS, *by Elizabeth C. Baker* 108

IN THE UNIVERSITY, *by Lee Hall* 130

Illustrations

Angelica Hesitating between Music and Painting:
 Angelica Kauffmann 11
Judith Beheading Holofernes: Artemisia Gentileschi 11
Self-Portrait: Lavinia Fontana 12
Portrait of the Artist Painting a Musician:
 Marguerite Gérard 13
Comtesse de Selve: Adélaide Labille-Guiard 14
Mrs. Fuller and Son: Maria Cosway 14
Self-Portrait: Marie Geneviève Brouliard 15
Philip II of Spain: Sofonisba Anguisciola 16
Still Life: Rachel Ruysch 17
Still-Life: Anna Peale 17
Military Attributes: Anne Vallayer-Coster 18
Portrait of a Girl: Philiberte Ledoux 18
Portrait of a Woman: Eva Gonzales 19
Portrait of Picasso: Marie Laurencin 19

Painting by Emily Mary Osborn 20

The Artist's Daughter: Elisabeth Vigée-Lebrun 21

Photograph showing Rosa Bonheur with Chief Sitting
 Bull, Buffalo Bill, and art dealer, Ronald Knoedler 22

The Duel: Rosa Bonheur 22

Triptych (I): Sophie Taeuber-Arp 23

*Rembrandt Seated among His Students Drawing from
 the Nude:* ink drawing by a pupil of Rembrandt 40

Painting by Zoffany, showing life-class at the Royal
 Academy 40

Ladies in a Studio: Daniel Chodowiecki 41

Houdon in His Studio: Louis-Léopold Boilly 41

Interior of David's Studio: Mathieu Cochereau 42

Ilya Efimovich Repin's studio: painting by his
 students 42-43

Photograph by Thomas Eakins, showing life-class at the
 Pennsylvania Academy ca. 1885 43

Detail of the Pienza Cope 49

Portrait of Charlotte du Val d'Ognes: Marie Charpentier 50

The Jolly Toper: Judith Leyster 51

Portrait of Marco dei Vescovi and Grandson:
 Marietta Tintoretto 51

The Church and *The Synagogue:*
 Sabina von Steinbach 52-53

*The Woman Clothed with the Sun and the Seven-
 headed Dragon:* from the Beatus Apocalypse of
 Gerona 54

Embrace: Rosalyn Drexler 70

Portrait of Donald Barthelme: Elaine de Kooning 71

Taxi: Loren MacIver 72

Gerard Malanga: Alice Neel 72

Three Thousand Miles to the Point of Beginning:
 Kay Sage 73

Study for the Gates to Times Square: Chryssa 74

Leda: Mary Frank 75

Hot Slash of Blue: Perle Fine 75

Women and Dog: Marisol 76
Portrait of the Artist and Her Husband:
 Louisa Matthiasdottir 76
Undulating Arrangement: I. Rice Pereira 77
Noir Veiné: Louise Bourgeois 78
Many-Headed Creature: Jean Follett 78
The Investiture of Charles, Prince of Wales:
 Sylvia Sleigh 79
Transfiguration: Charmion von Wiegand 80
Frieze: The Studio: Marcia Marcus 81
No. 2 from *Tropisms* series: Suzi Gablik 100
Untitled: Sylvia Stone 101
Untitled: Joan Mitchell 102
Descending: Bridget Riley 103
Dawn: Louise Nevelson 104
Untitled: Lynda Benglis 105
Window Work 1: Marjorie Strider 105
Portrait of Naomi Dash: Eleanor Antin 106
Break in the Middle: Rosemarie Castoro 107
Sign: Dorothea Rockburne 120
Shaman: Nancy Graves 121
The Tree: Agnes Martin 122
Contingent: Eva Hesse 123
Untitled metal and canvas sculpture: Lee Bontecou 124
Untitled (wrap-around painting): Jo Baer 125
Les Nanas: Niki de St. Phalle 126
Liquid Injection Thrust: Kiki Kogelnik 127
Balaton: Deborah Remington 128
First Anniversary: Joan Snyder 129
Formation and Cadence: Lee Hall 147
Erik's House: Barbro Ostlihn 148
Loosely Extended Red Field with Flat End:
 Cecile Abish 148
Steiner Form: Ruth Vollmer 149
Phoenix Flower: Miriam Schapiro 149
No More Stones: Mary Bauermeister 150

WHY HAVE THERE
BEEN NO GREAT
WOMEN ARTISTS? *

By
Linda Nochlin

Linda Nochlin, professor of art history at Vassar College, recently published a major text on realism (Penguin). Her specialty is Courbet and nineteenth century French art, but she has written on a range of subjects from Grünewald to modern art.

Why have there been no great women artists? The question is crucial, not merely to women, and not only for social or ethical reasons, but for purely intellectual ones as well. If, as John Stuart Mill so rightly suggested, we tend to accept whatever *is* as "natural," [1] this is just as true in the realm of academic investigation as it is in our social arrangements: the white Western male viewpoint, unconsciously accepted as *the* viewpoint of the art historian, is proving to be inadequate. At a moment when all disciplines are becoming more self-conscious—more aware of the nature of their presuppositions as exhibited in their own languages and structures—the current uncritical acceptance of "what is" as "natural" may be intellectually fatal. Just as Mill saw male domination as one of many social in-

* A shortened version of an essay in the anthology *Woman in Sexist Society: Studies in Power and Powerlessness.* Edited by Vivian Gornick and Barbara K. Moran. New York: Basic Books, 1971.

justices that had to be overcome if a truly just social order were to be created, so we may see the unconscious domination of a white male subjectivity as one among many intellectual distortions which must be corrected in order to achieve a more adequate and accurate view of history.

A feminist critique of the discipline of art history is needed which can pierce cultural-ideological limitations, to reveal biases and inadequacies *not merely in regard to the question of women artists, but in the formulation of the crucial questions of the discipline as a whole.* Thus the so-called woman question, far from being a peripheral subissue, can become a catalyst, a potent intellectual instrument, probing the most basic and "natural" assumptions, providing a paradigm for other kinds of internal questioning, and providing links with paradigms established by radical approaches in other fields. A simple question like "Why have there been no great women artists?" can, if answered adequately, create a chain reaction, expanding to encompass every accepted assumption of the field, and then outward to embrace history and the social sciences or even psychology and literature, and thereby, from the very outset, to challenge traditional divisions of intellectual inquiry.

The assumptions lying behind the question "Why have there been no great women artists?" are varied in range and sophistication. They run from "scientifically" proven demonstrations of the inability of human beings with wombs rather than penises to create anything significant, to relatively open-minded wonderment that women, despite so many years of near equality, have still not achieved anything of major significance in the visual arts.

The feminist's first reaction is to swallow the bait and attempt to answer the question as it is put: to dig up examples of insufficiently appreciated women artists

throughout history; to rehabilitate modest, if interesting and productive, careers; to "rediscover" forgotten flower-painters or David-followers and make a case for them; to demonstrate that Berthe Morisot was really less dependent upon Manet than one had been led to think—in other words, to engage in activity not too different from that of the average scholar, man or woman, making a case for the importance of his own neglected or minor master. Such attempts, whether undertaken from a feminist point of view, like the ambitious article on women artists which appeared in the 1858 *Westminster Review*,[2] or more recent scholarly reevaluation of individual women artists, like Angelica Kauffman or Artemisia Gentileschi,[3] are certainly well worth the effort, adding to our knowledge of women's achievement and of art history generally. A great deal still remains to be done in this area, but unfortunately, such attempts do not really confront the question "Why have there been no great women artists?"; on the contrary, by attempting to answer it, and by doing so inadequately, they merely reinforce its negative implications.

There is another approach to the question. Many contemporary feminists assert that there is actually a different kind of greatness for women's art than for men's—They propose the existence of a distinctive and recognizable feminine style, differing in both formal and expressive qualities from that of men artists and posited on the unique character of women's situation and experience.

This might seem reasonable enough: in general, women's experience and situation in society, and hence as artists, is different from men's, and certainly an art produced by a group of consciously united and purposely articulate women intent on bodying forth a group consciousness of feminine experience might indeed be stylistically identifi-

able as feminist, if not feminine, art. This remains within the realm of possibility; so far, it has not occurred.

No subtle essence of femininity would seem to link the work of Artemisia Gentileschi, Mme. Vigée-Lebrun, Angelica Kauffmann, Rosa Bonheur, Berthe Morisot, Suzanne Valadon, Kaethe Kollwitz, Barbara Hepworth, Georgia O'Keeffe, Sophie Taeuber-Arp, Helen Frankenthaler, Birdget Riley, Lee Bontecou, and Louise Nevelson, any more than that of Sappho, Marie de France, Jane Austen, Emily Brontë, George Sand, George Eliot, Virginia Woolf, Gertrude Stein, Anaïs Nin, Emily Dickinson, Sylvia Plath, and Susan Sontag. In every instance, women artists and writers would seem to be closer to other artists and writers of their own period and outlook than they are to each other.

It may be asserted that women artists are more inward-looking, more delicate and nuanced in their treatment of their medium. But which of the women artists cited above is more inward-turning than Redon, more subtle and nuanced in the handling of pigment than Corot at his best? Is Fragonard more or less feminine than Mme. Vigée-Lebrun? Is it not more a question of the whole rococo style of eighteenth-century France being "feminine," if judged in terms of a two-valued scale of "masculinity" versus "femininity"? Certainly if daintiness, delicacy, and preciousness are to be counted as earmarks of a feminine style, there is nothing fragile about Rosa Bonheur's *Horse Fair*. If women have at times turned to scenes of domestic life or children, so did the Dutch Little Masters, Chardin, and the impressionists—Renoir and Monet—as well as Morisot and Cassatt. In any case, the mere choice of a certain realm of subject matter, or the restriction to certain subjects, is not to be equated with a style, much less with some sort of quintessentially *feminine* style.

The problem lies not so much with the feminists' concept of what femininity in art is, but rather with a misconception of what art is: with the naïve idea that art is the direct, personal expression of individual emotional experience—a translation of personal life into visual terms. Yet art is almost never that; great art certainly never. The making of art involves a self-consistent language of form, more or less dependent upon, or free from, given temporally-defined conventions, schemata, or systems of notation, which have to be learned or worked out, through study, apprenticeship, or a long period of individual experimentation.

The fact is that there have been no great women artists, so far as we know, although there have been many interesting and good ones who have not been sufficiently investigated or appreciated—nor have there been any great Lithuanian jazz pianists or Eskimo tennis players. That this should be the case is regrettable, but no amount of manipulating the historical or critical evidence will alter the situation. There *are* no women equivalents for Michelangelo or Rembrandt, Delacroix or Cézanne, Picasso or Matisse, or even, in very recent times, for Willem de Kooning or Warhol, any more than there are black American equivalents for the same. If there actually were large numbers of "hidden" great women artists, or if there really should be different standards for women's art as opposed to men's— and, logically, one can't have it both ways—then what are feminists fighting for? If women have in fact achieved the same status as men in the arts, then the status quo is fine.

But in actuality, as we know, in the arts as in a hundred other areas, things remain stultifying, oppressive, and discouraging to all those—women included—who did not have the good fortune to be born white, preferably middle class and, above all, male. The fault lies not in our stars, our

hormones, our menstrual cycles, or our empty internal spaces, but in our institutions and our education—education understood to include everything that happens to us from the moment we enter, head first, into this world of meaningful symbols, signs, and signals. The miracle is, in fact, that given the overwhelming odds against women, or blacks, so many of both have managed to achieve so much excellence—if not towering grandeur—in those bailiwicks of white masculine prerogative like science, politics, or the arts.

In some areas, indeed, women have achieved equality. While there may never have been any great women composers, there have been great women singers; if no female Shakespeares, there have been Rachels, Bernhardts, and Duses. Where there is a need there is a way, institutionally speaking: once the public, authors, and composers demanded more realism and range than boys in drag or piping castrati could offer, a way was found to include women in the performing arts, even if in some cases they might have to do a little whoring on the side to keep their careers in order. And, in some of the performing arts, such as the ballet, women have exercised a near monopoly on greatness.

It is no accident that the whole crucial question of the conditions *generally* productive of great art has so rarely been investigated, or that attempts to investigate such general problems have, until fairly recently, been dismissed as unscholarly, too broad, or the province of some other discipline, like sociology. Yet a dispassionate, impersonal, sociologically- and institutionally-oriented approach would reveal the entire romantic, elitist, individual-glorifying and monograph-producing substructure upon which the profession of art history is based, and which has only recently

been called into question by a group of younger dissidents within it.

Underlying the question about women as artists, we find the whole myth of the Great Artist—subject of a hundred monographs, unique, godlike—bearing within his person since birth a mysterious essence, rather like the golden nugget in Mrs. Grass's chicken soup, called Genius.[4]

The magical aura surrounding the representational arts and their creators has, of course, given birth to myths since the earliest times. Interestingly enough, the same magical abilities attributed by Pliny to the Greek painter Lysippus in antiquity—the mysterious inner call in early youth; the lack of any teacher but Nature herself—is repeated as late as the nineteenth century by Max Buchon in his biography of Courbet. The fairy tale of the Boy Wonder, discovered by an older artist or discerning patron, often in the guise of a lowly shepherd boy,[5] has been a stock-in-trade of artistic mythology ever since Vasari immortalized the young Giotto, discovered by the great Cimabue while the lad was drawing sheep on a stone while guarding his flocks. Through mysterious coincidence, later artists like Domenico Beccafumi, Jacopo Sansovino, Andrea del Castagno, Andrea Mantegna, Francisco de Zurbarán and Goya were all discovered in similar pastoral circumstances. Even when the Great Artist was not fortunate enough to come equipped with a flock of sheep as a lad, his talent always seems to have manifested itself very early, independent of external encouragement: Filippo Lippi, Poussin, Courbet, and Monet are all reported to have drawn caricatures in their schoolbooks, instead of studying the required subjects. Michelangelo himself, according to his biographer and pupil, Vasari, did more drawing than studying as a child; Picasso passed all the examinations for

entrance to the Barcelona Academy of Art in a single day when only fifteen. (One would like to find out, of course, what became of all the youthful scribblers and infant prodigies who then went on to achieve nothing but mediocrity—or less—as artists.)

Despite the actual basis in fact of some of these *wunderkind* stories, the tenor of such tales is itself misleading. Yet all too often, art historians, while pooh-poohing this sort of mythology about artistic achievement, nevertheless retain it as the unconscious basis of their scholarly assumptions, no matter how many crumbs they may throw to social influence, ideas of the time, etc. Art-historical monographs, in particular, accept the notion of the Great Artist as primary, and the social and institutional structures within which he lived and worked as mere secondary "influences" or "background." This is still the golden-nugget theory of genius. On this basis, women's lack of major achievement in art may be formulated as a syllogism: If women had the golden nugget of artistic genius, it would reveal itself. But it has never revealed itself. Q.E.D. Women do not have the golden nugget of artistic genius. (If Giotto, the obscure shepherd boy, and van Gogh with his fits could make it, why not women?)

Yet if one casts a dispassionate eye on the actual social and institutional situation in which important art has existed throughout history, one finds that the fruitful or relevant questions for the historian to ask shape up rather differently. One would like to ask, for instance, from what social classes artists were most likely to come at different periods of art history—from what castes and subgroups? What proportion of major artists came from families in which their fathers or other close relatives were engaged in related professions? Nikolaus Pevsner points out in his discussion of the French Academy in the seven-

teenth and eighteenth centuries [6] that the transmission of the profession from father to son was considered a matter of course (as in fact it was with the Coypels, the Coustous, the Van Loos, etc.). Despite the noteworthy and dramatically satisfying cases of the great father-rejecting *révoltés* of the nineteenth century, one might well be forced to admit that in the days when it was normal for sons to follow in their fathers' or even their grandfathers' footsteps, a large proportion of artists, great and not-so-great, had artist fathers. In the rank of major artists, the names of Holbein, Dürer, Raphael, and Bernini immediately spring to mind; even in more rebellious recent times, one can cite Picasso and Braque as sons of artists (or, in the latter case, a house painter) who were early enrolled in the paternal profession.

As to the relationship of art and social class, an interesting paradigm for the question "Why have there been no great women artists?" is the question: "Why have there been no great artists from the aristocracy?" One can scarcely think, before the antitraditional nineteenth century at least, of any artist who sprang from the ranks of any class more elevated than the upper bourgeoisie; even in the nineteenth century, Degas came from the lower nobility—more like the haute bourgeosie—and only Toulouse-Lautrec, metamorphosed into the ranks of the marginal by accidental deformity, could be said to have come from the loftier reaches of the upper classes.

While the aristocracy has always provided the lion's share of patronage and the audience for art, it has rarely contributed anything but a few amateurish efforts to the actual creation of art, despite the fact that aristocrats, like many women, have had far more than their share of educational advantages, and plenty of leisure. Indeed, like women, they were often encouraged to dabble in art, even

becoming respectable amateurs, like Napoleon III's cousin, the Princess Mathilde, who exhibited at the official Salons, or Queen Victoria, who, with Prince Albert, studied art with no less a figure than Landseer himself. Could it be possible that genius is missing from the aristocratic make-up in the same way that it is from the feminine psyche? Or is it not rather that the kinds of demands and expectations placed before both aristocrats and women—the amount of time necessarily devoted to social functions, the very kinds of activities demanded—simply made total devotion to professional art production out of the question, and indeed unthinkable, both for upper-class males and for women generally.

When the right questions are finally asked about the conditions for producing art of which the production of great art is a subtopic, it will no doubt have to include some discussion of the situational concomitants of intelligence and talent generally, not merely of artistic genius. As Piaget and others have stressed, ability or intelligence is built up minutely, step by step, from infancy onward, and the patterns of adaptation-accommodation may be established so early that they may indeed *appear* to be innate to the unsophisticated observer. Such investigations imply that scholars will have to abandon the notion, consciously articulated or not, of individual genius as innate.[7]

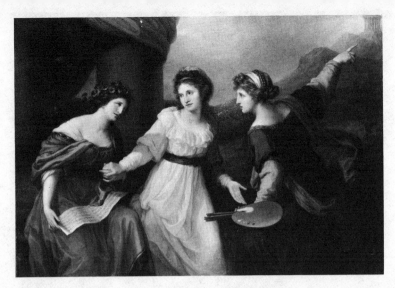

The Swiss-born Angelica Kauffmann, most of whose prolific career was spent in Italy, combines allegory with portraiture in *Angelica Hesitating between Music and Painting,* ca. 1765. Collection of R.D.G. Winn, London.

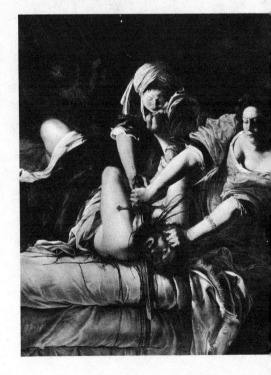

A banner for Women's Lib could be Artemisia Gentileschi's *Judith Beheading Holofernes* (Uffizi, Florence), one of this Roman painter's favorite subjects. This version dates ca. 1615-20, shortly after the scandal of her alleged promiscuous relations with her teacher.

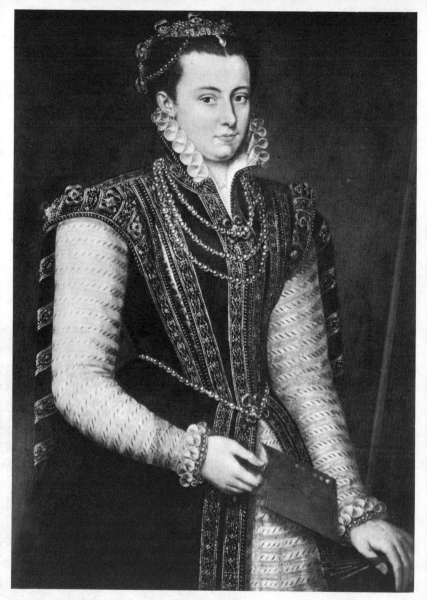

Lavinia Fontana's *Self-Portrait*, 1579, dates from the year she married
and moved from her native Bologna to become a fashionable portraitist in
Rome. Uffizi, Florence.

Marguerite Gérard, Fragonard's sister-in-law, was trained as an engraver, but turned to painting and did such ambitious work as *Portrait of the Artist Painting a Musician*. Hermitage, Leningrad.

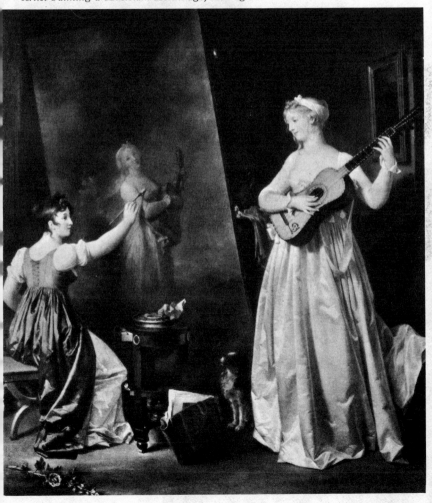

Adélaide Labille-Guiard's success at Versailles rivaled that of Mme. Vigée-Lebrun in the airy virtuosity of portraits like *Comtesse de Selve*. Wildenstein, New York.

Maria Cosway, born in Italy of English parents and trained in Rome, adopted the pastoral portrait style of Gainsborough and Lawrence. *Mrs. Fuller and Son*, ca. 1780. Private collection.

Despite the quality of pastels like Marie Geneviève Brouliard's *Self-Portrait*, ca. 1800, the popular medium was excluded from the Academy. Wildenstein, New York.

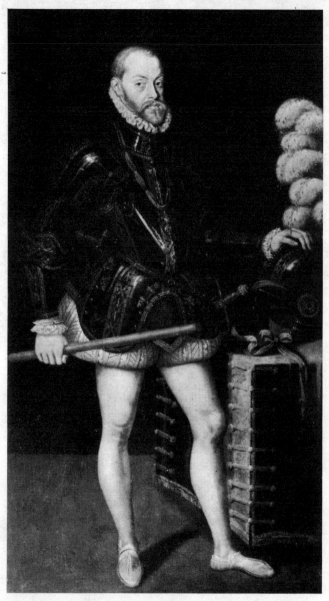

By Sofonisba Anguisciola, member of a noble family of
Cremona: *Philip II of Spain,* ca. 1570. National Portrait
Gallery, London.

Born into a wealthy Amsterdam family in 1664 (her father
was a noted professor of anatomy and botany), Rachel Ruysch
studied with Willem van Aelst and became a highly successful
and well-paid still-life painter. This brilliant composition
of fruit and insects, dated 1711, is in the Uffizi, Florence.

Like so many women painters of the past, Anna Peale (1791-
1878) was one of a family of painters, the Peales of Phila-
delphia (she was the daughter of James Peale and neice of
Charles W. Peale). Thus the obstacles many aspiring women
artists of her time would have faced were smoothed over for
her. *Still-life*. Knoedler, New York.

Almost as famous as her contemporaries Vigée-Lebrun and Labille-Guiard, Anne Vallayer-Coster was praised for painting "like a clever man." *Military Attributes*. Private collection, Texas.

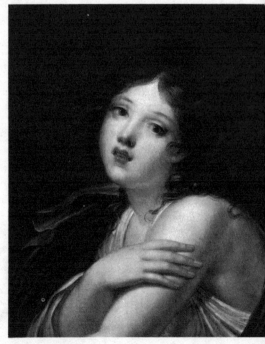

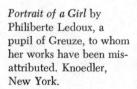

Portrait of a Girl by Philiberte Ledoux, a pupil of Greuze, to whom her works have been mis-attributed. Knoedler, New York.

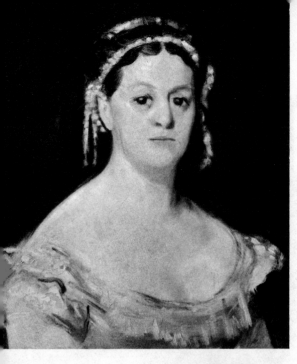

Eva Gonzales was Manet's pupil and close associate; he worked with her on this *Portrait of a Woman*, 1879. Wildenstein, New York.

Best known for her fragile studies of young girls, Marie Laurencin painted this bold portrait of Picasso in 1908. Collection of D. S. Stralem.

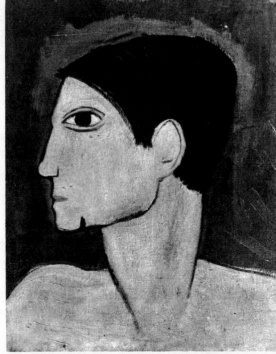

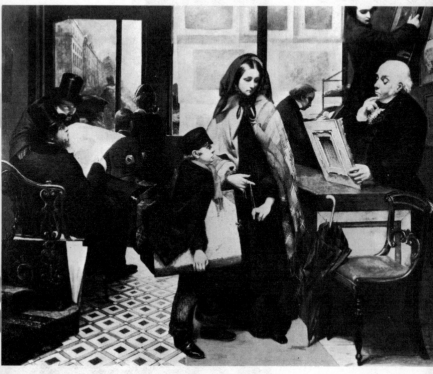

Possibly autobiographical, this painting by the little-known English painter
Emily Mary Osborn depicts the plight of a struggling woman painter
face to face with a crafty dealer.

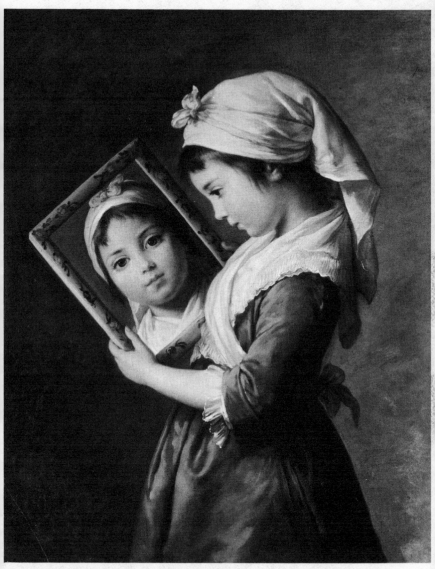

Elisabeth Vigée-Lebrun's immense following at the French court was largely
due to the patronage of Marie-Antoinette, whom she has been credited
with making sympathetic to posterity through her portraits of the queen.
The Artist's Daughter, ca. 1787, combines wit with Rococo sensibility.
Collection of James F. Donohue, New York.

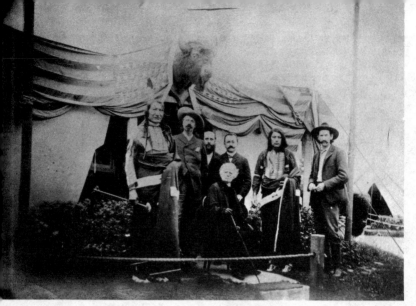

Rosa Bonheur, at the height of her fame, visiting Buffalo Bill's
touring company. At left is Chief Sitting Bull, next to him
Buffalo Bill. Behind Mme. Bonheur is her dealer, Ronald
Knoedler.

Rosa Bonheur: *The Duel*, 1895, 58¾ inches high. Knoedler,
New York. Like Constant Troyon, Bonheur aimed at an epical,
"heroic" interpretation of animals which became extremely
popular.

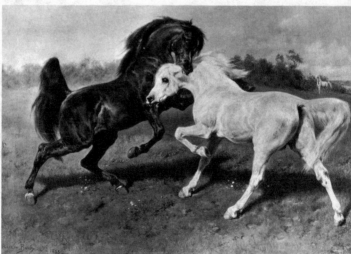

Sophie Taeuber-Arp: *Triptych (I)*, 1935, 20 inches wide.
Loeb-Krugier Gallery.

The Question of the Nude

We can now approach our question from a more reasonable standpoint. Let us examine such a simple but critical issue as availability of the nude model to aspiring women artists, in the period extending from the Renaissance until near the end of the nineteenth century. During this period, careful and prolonged study of the nude model was essential to the production of any work with pretentions to grandeur, and to the very essence of History Painting, then generally accepted as the highest category of art. Central to the training programs of academies of art since their inception late in the sixteenth and early in the seventeenth centuries was life drawing from the nude, generally male, model. In addition, groups of artists and their pupils often met privately for life-drawing sessions in their studios. It might be added that while individual artists and private academies employed female models extensively, the female nude was forbidden in almost all public art schools as late as 1850 and after—a state of affairs which Pevsner rightly designates as "hardly believable." [8]

Far more believable, unfortunately, was the complete unavailability to aspiring women artists of *any* nude models at all. As late as 1893, "lady" students were not admitted to life drawing at the official academy in London, and even when they were, after that date, the model had to be "partially draped."[9]

A brief survey of contemporary representations of life-drawing sessions reveals: an all-male clientele drawing from the female nude in Rembrandt's studio; men working from the male nude in an eighteenth-century academy; from the female nude in the Hague Academy; modelling

tion and its consequences, as well as the institutional nature of but one major facet of the necessary preparation for achieving proficiency, much less greatness, in art at a certain time. One could equally well have examined other dimensions of the situation, such as the apprenticeship system, the academic educational pattern which, in France especially, was almost the only key to success and which had a regular progression and set competitions, crowned by the Prix de Rome, which enabled the young winner to work in the French Academy in that city. This was unthinkable for women, of course, and women were unable to compete until the end of the nineteenth century, by which time the whole academic system had lost its importance anyway. It seems clear, to use France in the nineteenth century as an example (a country which probably had a larger proportion of women artists than any other—in terms of their percentage in the total number of artists exhibiting in the Salon) that "women were not accepted as professional painters." [10] In the middle of the century, there were a third as many women as men artists, but even this mildly encouraging statistic is deceptive when we discover that out of this relatively meager number, *none* had attended that major stepping stone to artistic success, the École des Beaux-Arts, only 7 percent had received a Salon medal, and *none* had ever received the Legion of Honor.[11] Deprived of encouragements, educational facilities, and rewards, it is almost incredible that even a small percentage of women actually sought a profession in the arts.

It also becomes apparent why women were able to compete on far more equal terms with men—and even become innovators—in literature. While art-making has traditionally demanded the learning of specific techniques and skills—in a certain sequence, in an institutional setting outside the home, as well as familiarity with a specific vocabulary

of iconography and motifs—the same is by no means true for the poet or novelist. Anyone, even a woman, has to learn the language, can learn to read and write, and can commit personal experiences to paper in the home. Naturally, this oversimplifies, but it still gives a clue as to the possibility of the existence of an Emily Dickinson or a Virginia Woolf, and their lack of counterparts (at least until quite recently) in the visual arts.

Of course, we have not even gone into the "fringe" requirements for major artists, which would have been, for the most part, both physically and socially closed to women. In the Renaissance and after, the Great Artist, aside from participating in the affairs of an academy, might be intimate and exchange ideas with members of humanist circles, establish suitable relationships with patrons, travel widely and freely, and perhaps become involved in politics and intrigue. Nor have we mentioned the sheer organizational acumen and ability involved in running a major atelier-factory, like that of Rubens. An enormous amount of self-confidence and worldly knowledge, as well as a natural sense of dominance and power, was needed by a great *chef d'école*, both in the running of the production end of painting, and in the control and instruction of numerous students and assistants.

The Lady's Accomplishment

Against the single-mindedness and commitment demanded of a *chef d'école*, we might set the image of the "lady painter" established by nineteenth century etiquette books and reinforced by the literature of the times. The insistence upon a modest, proficient, self-demeaning level

of amateurism—the looking upon art, like needlework or crocheting, as a suitable "'accomplishment" for the well-brought-up young woman—militated, and today still militates, against any real accomplishment on the part of women. It is this emphasis which transforms serious commitments to frivolous self-indulgence, busy work or occupational therapy, and even today, in suburban bastions of the feminine mystique, tends to distort the whole notion of what art is and what kind of social role it plays.

In Mrs. Ellis's widely read *The Family Monitor and Domestic Guide*, published before the middle of the nineteenth century—a book of advice popular both in the United States and in England—women were warned against the snare of trying too hard to excel in any one thing:

> It must not be supposed that the writer is one who would advocate, as essential to woman, any very extraordinary degree of intellectual attainment, especially if confined to one particular branch of study. . . . *To be able to do a great many things tolerably well, is of infinitely more value to a woman than to be able to excel in any one. By the former, she may render herself generally useful; by the latter, she may dazzle for an hour. By being apt, and tolerably well skilled in every thing, she may fall into any situation in life with dignity and ease—by devoting her time to excellence in one, she may remain incapable of every other. . . .* So far as cleverness, learning, and knowledge are conducive to woman's moral excellence, they are therefore desirable, and no further. *All that would occupy her mind to the exclusion of better things . . . all that would tend to draw away her thoughts from others and fix them on herself, ought to be avoided as an evil to her* [12] [italics mine].

This bit of advice has a familiar ring. Propped up by a bit of Freudianism—some tag lines about woman's chief

career, marriage, and the unfemininity of deep involvement with work rather than sex—it is the very mainstay of the feminine mystique to this day. Of course, such an outlook helps guard men from unwanted competition in their "serious" professional activities and assures them of "well-rounded" assistance on the home front, so they may have sex and family in addition to the fulfillment of their *own* specialized talent.

As far as painting or especially drawing is concerned, Mrs. Ellis found that it has one immediate advantage for the young lady over music—it is quiet and disturbs no one; in addition, "it is, of all other occupations, the one most calculated to keep the mind from brooding upon self, and to maintain that general cheerfulness which is a part of social and domestic duty. . . . It can also," she adds, "be laid down and resumed, as circumstance or inclination may direct, and that without any serious loss." [13]

Lest we feel that we have made a great deal of progress in this area in the past 100 years, I cite the contemptuous remark of a bright young doctor about his wife and her friends "dabbling" in the arts: "Well, at least it keeps them out of trouble." Now, as in the nineteenth century, women's amateurism, lack of commitment, snobbery, and emphasis on chic in their artistic "hobbies," feed the contempt of the successful, professionally committed man who is engaged in "real" work and can (with a certain justice) point to his wife's lack of seriousness. For such men, the "real" work of women is only that which directly or indirectly serves them and their children. Any other commitment falls under the rubric of diversion, selfishness, egomania or, at the unspoken extreme, castration. The circle is a vicious one, in which philistinism and frivolity mutually reinforce each other, today as in the nineteenth century.

Successes

But what of the small band of heroic women who, throughout the ages, despite obstacles, have achieved pre-eminence? Are there any qualities that may be said to have characterized them, as a group and as individuals? While we cannot investigate the subject in detail, we can point to a few striking general facts: almost all women artists were either the daughters of artist fathers, or later, in the nineteenth and twentieth centuries, had a close personal connection with a strong or dominant male artist. This is, of course, not unusual for men artists either, as we have indicated in the case of artist fathers and sons: it is simply true almost *without exception* for their feminine counterparts, at least until quite recently. From the legendary sculptor, Sabina von Steinbach, in the fifteenth century, who, according to local tradition, was responsible for the portal groups on the Cathedral of Strasbourg, down to Rosa Bonheur, the most renowned animal painter of the century—and including such eminent women artists as Marietta Robusti, daughter of Tintoretto, Lavinia Fontana, Artemisia Gentileschi, Elizabeth Chéron, Mme. Vigée-Lebrun, and Angelica Kauffman—all were the daughters of artists. In the nineteenth century, Berthe Morisot was closely associated with Manet, later marrying his brother, and Mary Cassatt based a good deal of her work on the style of her close friend, Degas. In the second half of the nineteenth century, precisely the same breaking of traditional bonds and discarding of time-honored practices that permitted men artists to strike out in directions quite different from those of their fathers enabled women—with additional difficulties, to be sure—to strike out on their own as well. Many of our more recent women artists, like

Suzanne Valadon, Paula Modersohn-Becker, Kaethe Koll-
witz, or Louise Nevelson, have come from nonartistic
backgrounds, although many contemporary and near-con-
temporary women artists have, of course, married artists.

It would be interesting to investigate the role of benign,
if not outright encouraging, fathers: both Kaethe Kollwitz
and Barbara Hepworth, for example, recall the influence of
unusually sympathetic and supportive fathers on their
artistic pursuits.

In the absence of any thoroughgoing investigation, one
can only gather impressionistic data about the presence or
absence of rebellion against parental authority in women
artists, and whether there may be more or less rebellion on
the part of women artists than is true in the case of men.
One thing, however, is clear: for a woman to opt for a
career at all, much less for a career in art, has required a
certain unconventionality, both in the past and at present.
And it is only by adopting, however covertly, the "mascu-
line" attributes of single-mindedness, concentration, tena-
ciousness, and absorption in ideas and craftsmanship for
their own sake, that women have succeeded, and continue
to succeed, in the world of art.

Rosa Bonheur

It is instructive to examine one of the most successful
and accomplished women painters of all time, Rosa Bon-
heur (1822-1899), whose work, despite the ravages wrought
upon its estimation by changes of taste, still stands as an
impressive achievement to anyone interested in the art of
the nineteenth century and in the history of taste generally.
Partly because of the magnitude of her reputation, Rosa

Bonheur is a woman artist in whom all the various con-
flicts, all the internal and external contradictions and strug-
gles typical of her sex and profession, stand out in sharp
relief.

The success of Rosa Bonheur emphasizes the role of in-
stitutions in relation to achievement in art. We might say
that Bonheur picked a fortunate time to become an artist.
She came into her own in the middle of the nineteenth
century, when the struggle between traditional history
painting, as opposed to the less pretestious and more
free-wheeling genre painting, landscape, and still-life was
won by the latter group. A major change in social and
institutional support for art was under way: with the rise
of the bourgeoisie, smaller paintings, generally of every-
day subjects, rather than grandiose mythological or re-
ligious scenes, were much in demand. In mid-nineteenth
century France, as in seventeenth-century Holland, there
was a tendency for artists to attempt to achieve some sort
of security in a shaky market situation by specializing in a
specific subject. Animal painting was then a very popular
field, and Rosa Bonheur was its most accomplished and
successful practitioner—followed only by the Barbizon
painter, Troyon, who was at one time so pressed for his
paintings of cows that he hired another artist to brush in
the backgrounds.

Daughter of an impoverished drawing master, Rosa Bon-
heur early showed her interest in art; she also exhibited
an independence of spirit and liberty of manner which
immediately earned her the label of tomboy. Although her
attitude toward her father is somewhat ambiguous, clearly,
he was influential in directing her toward her life's work.
Raimond Bonheur had been an active member of the short-
lived Saint-Simonian community, established in the third
decade of the nineteenth century by "Le Père" Enfantin

at Menilmontant. Although in her later years Rosa Bonheur might have made fun of some of the more farfetched eccentricities of the members of that community, and disapproved of the additional strain which her father's apostolate placed on her overburdened mother, it is obvious that the Saint-Simonian ideal of equality for women—they disapproved of marriage, their trousered feminine costume was a token of emancipation, and their spiritual leader, Le Père Enfantin, made extraordinary efforts to find a Woman Messiah to share his reign—made a strong impression on her as a child and may have influenced her future course of behavior.

"Why shouldn't I be proud to be a woman?" she exclaimed to an interviewer. "My father, that enthusiastic apostle of humanity, many times reiterated to me that woman's mission was to elevate the human race, that she was the Messiah of future centuries. It is to his doctrines that I owe the great, noble ambition I have conceived for the sex which I proudly affirm to be mine, and whose independence I will support to my dying day." [14] When she was still hardly more than a child, he instilled in her the ambition to surpass Mme. Vigée-Lebrun, certainly the most eminent model she could be expected to follow, and gave her early efforts every possible encouragement. At the same time, the spectacle of her uncomplaining mother's decline from overwork and poverty might have been an even stronger influence on her decision to control her own destiny and never to become the unpaid slave of a man and children through marriage.

In those refreshingly straightforward pre-Freudian days, Rosa Bonheur could explain to her biographer that she had never wanted to marry for fear of losing her independence—too many young girls let themselves be led to the altar like lambs to the sacrifice, she maintained—without

any awkward sexual overtones marring the ring of pure practicality. Yet at the same time that she rejected marriage for herself and implied an inevitable loss of selfhood for any woman who engaged in it, she, unlike the Saint-Simonians, considered marriage "a sacrament indispensable to the organization of society."

While remaining cool to offers of marriage, she joined in a seemingly cloudless, lifelong and apparently completely platonic union with a fellow woman artist, Nathalie Micas, who evidently provided her with the companionship and emotional warmth which she, like most human beings, needed. Obviously the presence of this sympathetic friend did not seem to demand the same sacrifice of commitment to her profession which marriage would have entailed. In any case, the advantages of such an arrangement for women who wished to avoid the distraction of children in the days before reliable contraception are obvious.

Yet at the same time that she frankly rejected the conventional feminine role of her times, Rosa Bonheur still was drawn into what Betty Friedan has called the "frilly blouse syndrome," which even today compels successful professional women to adopt some ultrafeminine item of clothing or insist on proving their prowess as pie bakers.[15] Despite the fact that she had early cropped her hair and adopted men's clothes as her habitual attire (following the example of George Sand, whose rural romanticism exerted a powerful influence over her artistic imagination), to her biographer she insisted, and no doubt sincerely believed, that she did so only because of the specific demands of her profession. Indignantly denying rumors to the effect that she had run about the streets of Paris dressed as a boy in her youth, she proudly provided her biographer with a daguerreotype of herself at sixteen years, dressed in perfectly conventional feminine fashion, except for her shorn

head, which she excused as a practical measure taken after the death of her mother: "who would have taken care of my curls?" she demanded.[16]

She rejected a suggestion that her trousers were a symbol of bold emancipation:

> I strongly blame women who renounce their customary attire in the desire to make themselves pass for men.
> . . . If I had found that trousers suited my sex, I would have completely gotten rid of my skirts, but this is not the case, nor have I ever advised my sisters of the palette to wear men's clothes in the ordinary course of life. If, then, you see me dressed as I am, it is not at all with the aim of making myself interesting, as all too many women have tried, but simply in order to facilitate my work. Remember that at a certain period I spent whole days in the slaughterhouses. Indeed, you have to love your art in order to live in pools of blood. . . . I had no alternative but to realize that the garments of my own sex were a total nuisance. That is why I decided to ask the Prefect of Police for the authorization to wear masculine clothing.[17] But the costume I am wearing is my working outfit, nothing else. . . . I am completely prepared to put on a skirt, especially since all I have to do is to open a closet to find a whole assortment of feminine outfits.[18]

It is somewhat pathetic that this highly successful world-renowned artist—unsparing of herself in the painstaking study of animal anatomy; diligently pursuing her bovine or equine subjects in the most unpleasant surroundings; industriously producing popular canvases throughout the course of a lengthy career; firm, assured, and incontrovertibly masculine in her style; winner of a first medal in the Paris salon; Officer of the French Legion of Honor; Commander of the Order of Isabella the Catholic and the Order of Leopold of Belgium; friend of Queen Victoria—

should feel compelled late in life to justify and qualify her perfectly reasonable assumption of masculine ways, for any reason whatsoever; it is more pathetic still that she should feel compelled to attack her less modest, trouser-wearing sisters. Yet her conscience, despite her supportive father and worldly success, still condemned her for not being a "feminine" woman.

The difficulties imposed by society's implicit demands on the woman artist continue to add to the difficulty of their enterprise even today. Compare, for example, the noted contemporary sculptor Louise Nevelson, with her combination of utterly "unfeminine" dedication to her work and her conspicuously "feminine" false eyelashes. She admits that she got married at seventeen, despite the certainty that she couldn't live without creating, because "the world said you should get married." [19] Even in the case of these two outstanding artists—and whether we like *The Horsefair* or not, we still must admire Rosa Bonheur's achievement—the voice of the feminine mystique with its potpourri of ambivalent narcissism and internalized guilt subtly dilutes and subverts that total inner confidence, that absolute certitude and self-determination (moral and esthetic), demanded by the highest and most innovative work in art.

Conclusion

Hopefully, by stressing the *institutional*, or the public, rather than the *individual*, or private, preconditions for achievement in the arts, we have provided a paradigm for the investigation of other areas in the field. By examining in some detail a single instance of deprivation or disad-

vantage—the unavailability of nude models to women art students—we have suggested that it was indeed *institutionally* impossible for women to achieve excellence or success on the same footing as men, *no matter what* their talent, or genius. The existence of a tiny band of successful, if not great, women artists throughout history does nothing to gainsay this fact, any more than does the existence of a few superstars or token achievers among the members of any minority groups.

What is important is that women face up to the reality of their history and of their present situation. Disadvantage may indeed be an excuse; it is not, however, an intellectual position. Rather, using their situation as underdogs and outsiders as a vantage point, women can reveal institutional and intellectual weaknesses in general, and, at the same time that they destroy false consciousness, take part in the creation of institutions in which clear thought and true greatness are challenges open to anyone—man or woman—courageous enough to take the necessary risk, the leap into the unknown.

NOTES

1. John Stuart Mill, "The Subjection of Women" (1869) in *Three Essays by John Stuart Mill,* World's Classics Series (London, 1966), p. 441.

2. "Women Artists," a review of *Die Frauen in die Kunstgeschichte* by Ernst Guhl in *The Westminster Review* (American Edition) 70 (July 1858): 91–104. I am grateful to Elaine Showalter for having brought this review to my attention.

3. See, for example, Peter S. Walch's excellent studies of Angelica Kauffman or his doctoral dissertation, "Angelica Kauffmann," Princeton University, 1967. For Artemisia Gentileschi, see R. Ward Bissell, "Artemisia Gentileschi—A New Documented Chronology," *Art Bulletin* 50 (June 1968): 153–168.

4. For the relatively recent genesis of the emphasis on the artist as the nexus of esthetic experience, see M. H. Abrams, *The Mirror and the Lamp: Romantic Theory and the Critical Tradition* (New York: Oxford University Press, 1953) and Maurice Z. Shroder, *Icarus: The Image of the Artist in French Romanticism* (Cambridge: Harvard University Press, 1961).

5. A comparison with the parallel myth for women, the Cinderella story, is revealing: Cinderella gains higher status on the basis of a passive, "sex-object" attribute—small feet (shades of fetishism and Chinese foot-binding!)—whereas the Boy Wonder always proves himself through active accomplishment. For a thorough study of myths about artists, see Ernst Kris and Otto Kurz, *Die Legende vom Künstler: Ein Geschichtlicher Versuch* (Vienna, 1934).

6. Nikolaus Pevsner, *Academies of Art, Past and Present* (Cambridge, England: The University Press, 1940; New York: Macmillan, 1940), p. 96f.

7. Contemporary directions in art itself—earthworks, conceptual art, art as information, etc.—certainly point *away* from emphasis on the individual genius and his salable products; in art history, Harrison C. White and Cynthia A. White, *Canvases and Careers: Institutional Change in the French Painting World* (New York: Wiley, 1965) opens up a fruitful new direction of investigation, as does Nikolaus Pevsner's pioneering *Academies of Art* (see Note 6); Ernst Gombrich and Pierre Francastel, in their very different ways, have always tended to view art and the artist as part of a total situation, rather than in lofty isolation.

8. Female models were introduced in the life class in Berlin in 1875, in Stockholm in 1839, in Naples in 1870, at the Royal College of Art in London, after 1875. Pevsner, *op. cit.*, p. 231. Female models at the Pennsylvania Academy of the Fine Arts wore masks to hide their identity as late as about 1866—as attested to in a charcoal drawing by Thomas Eakins—if not later.

9. Pevsner, *op. cit.*, p. 231.

10. White and White, *op. cit.*, p. 51.

11. *Ibid.*, Table 5.

12. Mrs. Ellis, "The Daughters of England: Their Position in Society, Character, and Responsibilities" in *The Family Monitor and Domestic Guide* (New York, 1844), p. 35.

13. *Ibid.*, 38–39.

14. Anna Klumpke, *Rosa Bonheur: Sa Vie, son oeuvre* (Paris: E. Flammarion, 1908), p. 311.

15. Betty Friedan, *The Feminine Mystique* (New York: Norton, 1963), p. 158.

16. Klumpke, *op. cit.*, p. 166.

17. Paris, like many cities even today, had laws on its books against impersonation.

18. Klumpke, *op. cit.*, pp. 308–309.

19. Cited in Elizabeth Fisher, "The Woman as Artist, Louise Nevelson," *Aphra* I (Spring 1970): 32.

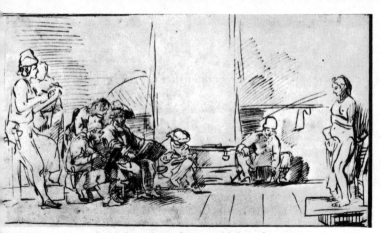

In Rembrandt's studio, only male students could draw from a
nude model. This ink drawing, *Rembrandt Seated among His
Students Drawing from the Nude,* by a pupil of Rembrandt, is
in the Staatliche Kunstsammlungen, Weimar.

In Zoffany's painting of the life-class at the Royal Academy,
1772, all the members are present except for Angelica
Kauffmann, who for reasons of propriety has a stand-in—her
portrait on the wall.

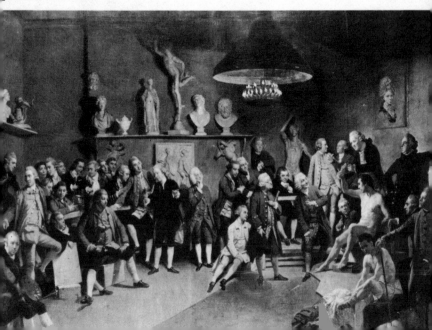

Even female models had to be clothed for female artists in the eighteenth century. Daniel Chodowiecki's *Ladies in a Studio*. Berlin Museum.

Boilly's *Houdon in His Studio* (Cherbourg Museum) shows male artists working from a seated male nude at the beginning of the nineteenth century.

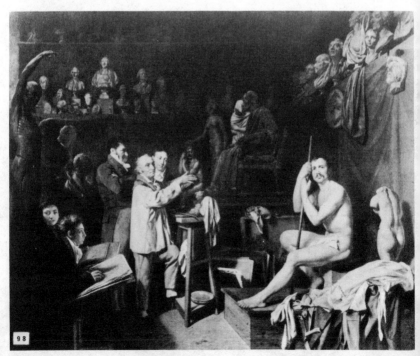

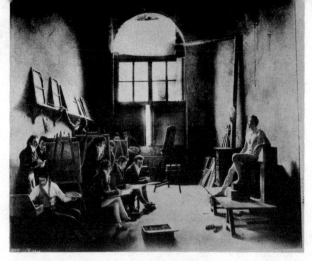

Although women were not allowed to draw from nude models of either sex, men faced no such restrictions: Mathieu Cochereau's *Interior of David's Studio* from the Salon of 1814. Louvre.

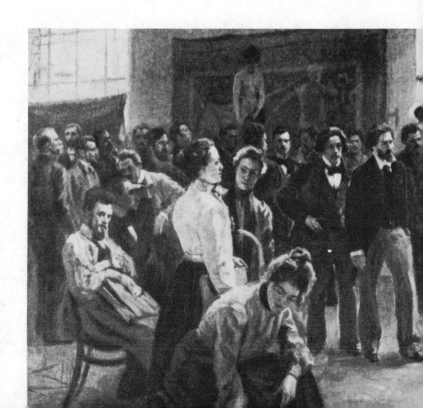

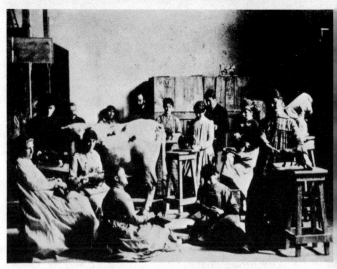

In this photograph by Thomas Eakins of one of his life-classes at the Pennsylvania Academy around 1885, a cow serves as a model for the women students. In the 1880s, women did take part in life-classes in which, segregated from the men students, they worked both from the male and the female model. However, when Eakins removed the loin-cloth from a male model during an anatomy lecture to women students, it precipitated his discharge from the Academy staff.

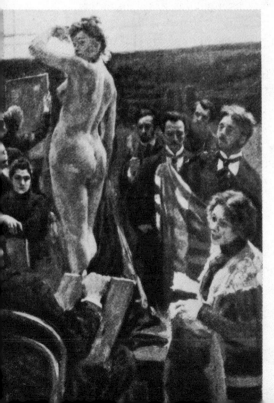

By the time women were admitted to life classes, academic art was on the wane. This 1898 painting of the Russian artist Repin's studio is a collective work by his students.

GREAT WOMEN ARTISTS

By
Thomas B. Hess

The vexing question "Why Have There Been No Great Women Artists?" is largely answered in this volume by Prof. Linda Nochlin; she shows that the question itself is a symptom of male prejudices and stereotypes whose irrelevance distorts much appreciation of art and undermines many scholary assumptions in art history.

But the illustrations accompanying Prof. Nochlin's and some of the other essays in these pages suggest that a clause could be added to her question which makes it even more equivocal. It could be phrased: "Why Have There Been No Great Women Artists *even though women have produced great works of art?*"

Take the famous portrait of Mlle. Charlotte du Val d'Ognes which was bequeathed to the Metropolitan Museum by Isaac Dudley Fletcher in 1917. *Art News*'s files preserve the press-release issued on the occasion; it states that:

"As one of the masterpieces of this artist, the Fletcher picture will henceforth be known in the art world as 'the New York David,' just as we speak of the *Man with a Fur Cap* of the Hermitage, or the Sistine Madonna of Dresden Mr. Fletcher is said to have paid $200,000 for this great David."

(As the press-release was prepared in collaboration with the Wildenstein gallery—the gallery that sold the portrait—there is no reason to doubt the quoted price, nor that Fletcher paid the contemporary equivalent of about $2 million.)

The painting was unanimously accepted by a consensus of experts as one of the great masterpieces by Jacques-Louis David, who founded the dominant nineteenth-century style of neoclassicism—until about ten years ago when Prof. Charles Sterling published in the *Bulletin* of the Metropolitan Museum an essay proving (as conclusively as such matters ever can be proved) that the portrait is not by J.-L. David and that it is probably by Constance-Marie Charpentier. She had been one of David's pupils, and her extraordinary power and originality was proclaimed, all unawares, by four generations of male-chauvinist art experts.

(Is Mr. Fletcher's $2 million, one wonders, a record price for a woman artist?)

Nor is the portrait of Mlle. Charlotte an exceptional instance. The jolly toper in the Rijksmuseum, Amsterdam, for years was a favorite, world-famous Frans Hals—until modern cleaning revealed the characteristic initial "J" which identified it as by Judith Leyster, one of Hals's most brilliant followers. Also uncovered was a date, 1629, making it the earliest known work by Leyster, whose natural gifts (what Prof. Nochlin calls the "golden nugget of genius") enabled her to rival the greatest master of the brushstroke at the age of nineteen!

Or take the Tintoretto portrait of Marco dei Vescovi, the artist's father-in-law, for years a beloved and praised masterwork in the Vienna museum—but not so pleasing to scholars after 1920, when Venturi, noting that it is signed with an "M," attributed it to Jacopo Tintoretto's daughter

Marietta. Documents indicate that Marietta was a well-known painter with a fluent production, but our museums claim almost no works from her hand—which indicates, of course, that three centuries of dealers and curators have "promoted" her pictures into her father's oeuvre and have heaped extravagant analyses and eulogies on her work, while effacing her name.

We must grant, therefore, that women have produced works of art in the same league as the major masters, but as we do so the question shifts to the singularly ambiguous, modern issue of Originality. For if Constance-Marie Charpentier, Judith Leyster, and Marietta Tintoretto were, respectively, as good as Jacques-Louis David, Frans Hals and Jacopo Tintoretto at their own game, they were not innovators of style. They stayed close to tradition and example. However, once the issue of Originality is raised, it becomes apparent that Prof. Nochlin's argument around the question "Why Have There Been No Great Women Artists?" is largely concerned with the last 500 years of art history, that is with art since the Renaissance, when originality and individuality were honored above all other qualities as the prerequisites of Genius.

But the history of art is some 5,000 years old. Who is to say that a woman did not design the pyramids of Egypt or the Hanging Gardens of Babylon? Furthermore, as research in the Middle Ages progresses, individual artists' names are beginning to be identified. There is Nicholas of Verdun, superstar in the magnificent exhibition of "The Year 1200" at the Metropolitan Museum in 1970. And there is Giselbertus of Autun, artist-hero of André Malraux's characteristically swashbuckling excursion into the Romanesque. But there is also the nun Erde who, with her collaborator, the monk Emeterius, painted the illustrations in the Beatus Apocalypse of Gerona and in its hundred pictures created

some of the supreme masterpieces of the tenth century—certainly on the level of accomplishment demanded of women by Prof. Nochlin in her Michelangelo-Cézanne lineup. And what about Sabina von Steinbach, sculptor-daughter of sculptor Erwin von Steinbach? When her father died in the middle of his work on the Strasbourg Cathedral, Sabina took over the campaign, and on its South Portal carved the statues of *The Synagogue* and of *The Christian Church* (1230–40) which for many connoisseurs, including Focillon, surpass her father's work in originality of concept as well as in depth of feeling and esthetic rigor.

One of the great masterpieces of the Middle Ages is the Bayeux embroidery, which celebrates the Norman conquest of England; scholars believe that it probably was designed by a woman, as well as executed by nuns. And the celebrated *Opus Anglicanum,* England's greatest contribution to the international arts of the thirteenth and fourteenth centuries, was the product of women—of embroiderers who perfected their craft to a high art and who, it is thought, also were responsible for the designs that made these vestments among the most prized treasures of the Christian world.

So as one takes a longer view of history, one can suggest a categorical answer to Prof. Nochlin's question—Yes, there have been great women artists. And one can add the astonishing corollary— Women, or at least exceptionally gifted women, were freer and less subject to institutional and social pressures in the Middle Ages than they have been under the rule of the individual which was promulgated with the Renaissance.

In another connection, I have suggested that late twentieth-century civilization is rushing full-tilt backwards to the Gothic. There is evidence in the verticality of our cities (Houston has the silhouette of Chartres), in our children's

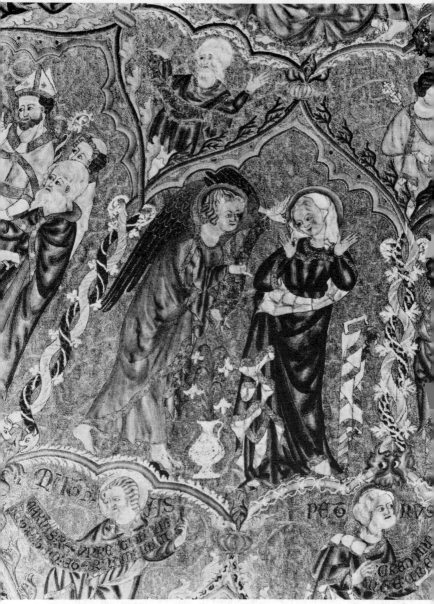

A great English medieval embroidery, the Pienza Cope (detail), 1315–35, with twenty-seven scenes from the life of the Virgin, St. Margaret, and St. Catharine. It is said to have been given to Pope Pius II by Thomas Paleologus during the Turkish occupation of the Peloponessus. The Pope gave it to the Pienza Cathedral in 1492. Much of such embroidery has been thought to be the work of nuns.

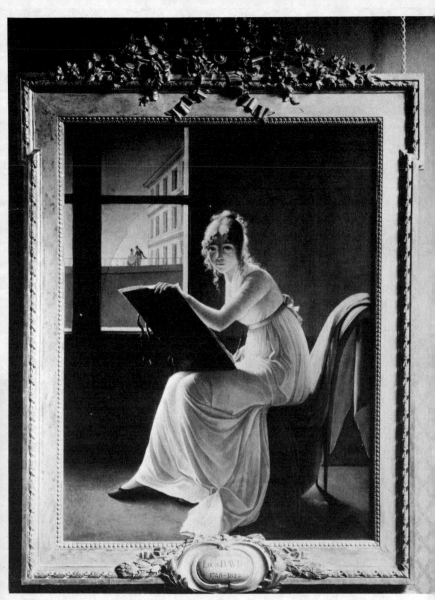

Perhaps the greatest picture ever painted by a woman is the portrait of
Charlotte du Val d'Ognes, ca. 1800, 63½ inches high, long attributed to the
great neoclassic master J.-L. David, now considered to be by Constance-
Marie Charpentier, who had worked in David's studio. It was purchased
in 1917 for $200,000 and bequeathed the same year to the Metropolitan
Museum by Isaac Dudley Fletcher.

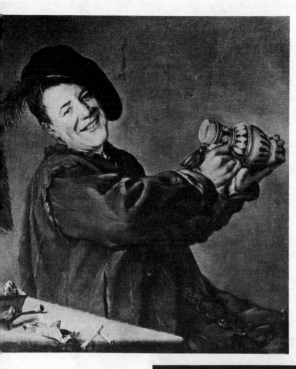

Judith Leyster's *The Jolly Toper* was called a Frans Hals until the discovery of her typical signature, "J*," and the date 1629, in upper right center. Rijksmuseum, Amsterdam.

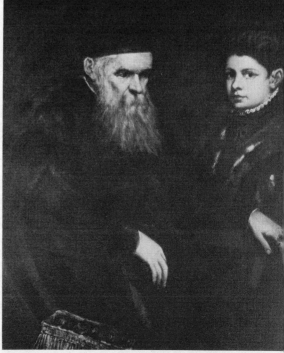

Marietta Tintoretto's *Portrait of Marco dei Vescovi and Grandson,* ca. 1570, long attributed to her father Jacopo, is now accepted as her work. Kunsthistorisches Museum, Vienna.

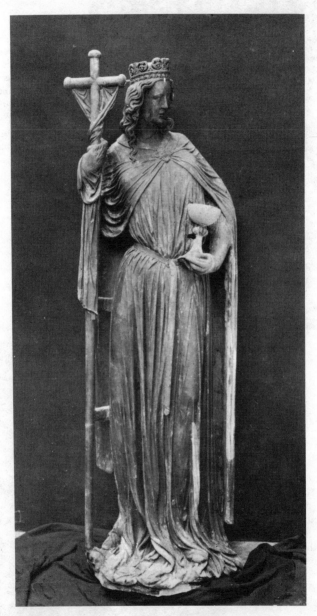

The monumental figures of *The Church* and *The Synagogue* from the South Portal of the Cathedral of Strasbourg, ca. 1225, are attributed to Sabina von Steinbach, daughter of the master-sculptor of the cathedral, who died before the completion of the work.

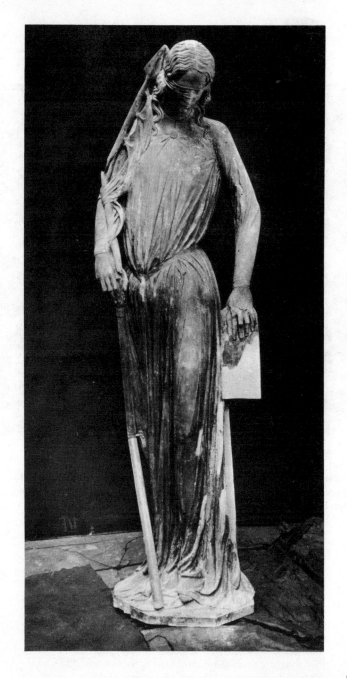

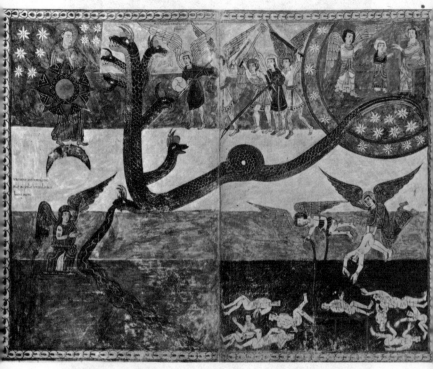

The name of a nun, Erde, and that of a monk, appear in the colophon of
the Beatus Apocalypse of Gerona as the authors of over 100 paintings in
this monument of medieval illumination, from Asturias, Spain, 975. This
two-page spread illustrates St. John's vision of *The Woman Clothed with
the Sun and the Seven-headed Dragon,* 13¼ inches high.

WHY HAVE THERE BEEN NO GREAT WOMEN ARTISTS? TEN REPLIES

Dialogue, By Elaine de Kooning with Rosalyn Drexler

The Hermaphrodite, by Bridget Riley

Do Your Work, by Louise Nevelson

Women without Pathos, by Eleanor Antin

The Double-Bind, by Suzi Gablik

Healthy Self-Love, by Sylvia Stone

Moving Out, Moving Up, by Marjorie Strider

Social Conditions Can Change, by Lynda Benglis

Artists Transgress All Boundaries,
 by Rosemarie Castoro

DIALOGUE

By
Elaine de Kooning
with Rosalyn Drexler

Elaine de Kooning is a well-known painter and writer. She has held professorships at the Carnegie-Mellon University and the University of Pennsylvania.

Rosalyn Drexler had a first show of sculpture at the Reuben Gallery in New York in 1959. During the 1960s she became well known as a painter, novelist, and playwright. in 1971 a show of her paintings was held in New York at the Rockland Community College. Ms. Drexler's third novel, *To Smithereens,* was recently published by New American Library.

Elaine de Kooning: Well, first—that term, "women artists." I was talking to Joan Mitchell at a party ten years ago when a man came up to us and said, "What do you women artists think . . ." Joan grabbed my arm and said, "Elaine, let's get the hell out of here." That was my first response to Linda Nochlin's essay. I was curious about how a man would react. Alex Katz thought it would be a cop-out to answer the piece. Sherman (Drexler) thought it would be a cop-out not to answer it. John Cage thought the question "divisive and an over-simplification." I agree with all of them.

Rosalyn Drexler: There aren't that many great artists in history for the name of this piece to make any sense. Ms. Nochlin says "there are no women equivalents for Michelangelo or Rembrandt, Delacroix or Cézanne, Picasso or Matisse." There are no male equivalents for them either.

However, I don't object to being called a woman artist as long as the word "woman" isn't used to define the kind of art I create.

E: To be put in any category not defined by one's work is to be falsified. We're artists who happen to be women or men among other things we happen to be—tall, short, blonde, dark, mesomorph, ectomorph, black, Spanish, German, Irish, hot-tempered, easy-going—that are in no way relevant to our being artists.

R: Well, Ms. Nochlin thinks otherwise. She holds up the idea that a "group of consciously united women . . . bodying forth a group consciousness of feminine experience might . . . be stylistically identifiable as feminist, if not feminine, art." She goes on, "This remains within the realm of possibility; so far it has not occurred." I can't think of anything more fortunate. No one thinks collectively unless they are involved with propaganda. The Black Panthers, I believe, demand a certain kind of art that will promote their dogma, an art that may be defined as "black." But the black artist, though he or she may illustrate certain concerns, wishes to be thought of first as an artist. Also there is ethnic art which is immediately recognizable as having a collective sensibility. But here again, women as well as men are absorbed into this style. You can't tell which sex or race created the work. However, the mores of a culture might determine whether a man or a woman is the artist. For instance, have there been any women sign painters? In England or during Revolutionary times in the U.S.?

E: Let's not get dragged into the past. I gave a talk on this subject in Provincetown in 1949 with the title: "Women fill the art schools; men do the painting." I was working at the time on a piece for *Mademoiselle* based on my experience of art schools. I began to dig around in early American painting—primitives, amateurs—all of which

brought to mind Virginia Woolf's remark: "Anonymous was a woman"—which was reinforced when I began to scrounge around for European women artists and found them turning up in the studios of Renaissance masters. I began to have my suspicions about any painting of a woman with a book or a drawing pad or a letter in her lap—the self-portrait pose (at the time, I was still working on a series of self-portraits begun five years before), particularly the beautiful painting of a woman before a window by David, which has since been attributed to Constance-Marie Charpentier. I began to get bogged down in all sorts of eccentric information and fascinating personalities like Marie Bashkirtseff and her fantasy life. The last straw was when I came across an extraordinary example of Magic-Realism by a nineteenth-century Swiss woman. I looked her up and it turned out she was born without arms and painted with her feet. That was when I decided it was not a subject for a fashion magazine, and I gave up the whole project. Since then, a good many women artists have emerged. But before the twentieth century, there's no doubt that there were very few ways for a woman to become a serious, full-time professional.

R: Stendhal said 150 years ago: "All the geniuses who are born women are lost to the public good." And Simone de Beauvoir, in *The Second Sex*, said: "To tell the truth, one is not born a genius, one becomes a genius and the feminine situation has, up to the present, rendered this becoming practically impossible."

E: Well, in writing and poetry a few of them managed to survive, as Ms. Nochlin points out. I was discussing this with the poet David Shapiro and he read me an excerpt from a letter of Rimbaud's: "When the infinite servitude of women shall have ended, she will be able to live by and for herself; man—hitherto abominable—will give her freedom,

and she too will be a poet. Women will discover the un-known. Will her world be different from ours? She will discover strange, unfathomable things—repulsive, delicious. We shall *take* them." David, by his intonation and a sly giggle, gave "take" the unmistakable meaning of "con-fiscate." But then he relented and added the next line. "We shall understand them." The letter, he said, was written May 15, 1871. After we talked, I wondered just what Emily Dickinson was doing that day. It turned out May 15th was the day she died—but 15 years later, so there she was, 40 years old, completely absorbed in her work, un-known to all but a few choice friends. Maybe she was writing "I'm Nobody! Who Are You?". George Eliot, George Sand, the Brontës took men's pen-names—but women's state of mind now is completely different. When Ms. Nochlin says: "If women have in fact achieved the same status as men in the arts, then the status quo is fine." Well, I think the status quo in the arts *is* fine as it is—in this country at least, women have exactly the same chance that men do. There are the same schools, museums, gal-leries, books, art stores. There are no obstacles in the way of a woman becoming a painter or sculptor, other than the usual obstacles that any artist has to face.

R: You're talking about woman as impetus to herself, but what this woman who wrote the article may mean is that there are people who manipulate the art world—who can decide by *tumeling* up business, by talking, by maybe buying articles, by collecting, by publishing—that they can build a reputation, and the people who do this may feel, subliminally—no matter what they say—that they wouldn't do this for a woman or, at least, not for many women.

E: There's no doubt, in terms of the numbers of women painters in this country, that women are not bought by collectors to the same extent that men are. On a given level,

let's say, in a given age group, they're not exhibited as adequately in museums, are not given teaching posts at the universities. I've taught and lectured at various universities around the country in the past twelve years, and it's noticeable how very few women art teachers there are on the college level. So you're right—there is prejudice in terms of the whole PR mechanism—but the question we're discussing is not recognition; the question is the idea of being an artist.

R: Yes, but then the adjective *Great* also has to do with what's available for coming generations to see. In other words, it has to *be* there, it has to be *in* the collections, it has to be *in* the museums.

E: I know, but don't think you can force recognition. Any artist, no matter what his gifts, faces neglect. I remember twenty-two years ago, Bill (de Kooning) was invited to fill out an application by the Guggenheim Foundation. He was sent a form with an accompanying note saying that they had asked Meyer Schapiro to recommend some avant-garde artists because none of them seemed to be applying. Up until then, Bill just assumed it would be a waste of time to apply, but now he thought: Aha, so *that's* the way they do it, and he filled out the application, and they promptly turned him down. He was furious because he had put himself in the position of being rejected. In fact he was furious even before he got rejected when he realized he had to bother a lot of busy people for recommendations and then fill out those dreary, endless forms—particularly because he had nothing to fill in, no list of one-man shows, no museum collections, no well-known private collections, no teaching posts, nothing. For the required statement of aim, he couldn't think of anything to put down but "I want to paint and I'll continue to paint whether I get this grant or not." He ended his request rather pertinently,

I thought, by writing, "And by the way, I'm the one that should be asking the questions."

That kind of neglect is always going on. Bucky Fuller, who was one of Bill's sponsors at that time, told me a couple of years ago that he had written thirty letters of recommendation to the Guggenheim Foundation over the years at a great expense of time and thought and that not one of his applicants had received a grant. He put this in writing to them that year—I think it was '67. The thirty letters, he informed them, would constitute a book for which he'd like to have a Guggenheim grant to compare the subsequent careers of his rejected applicants with the recipients of the grants. And for the first time, one of his applicants was accepted—obviously a nervous reaction on their part.

Or look at the recent show at the Metropolitan that was supposed to cover the New York scene from 1940 to 1970. That was the most outrageous case of neglect on a large scale that I can think of. The inclusions were fine but the exclusions—artists whose work was indispensable to the character of the '40s and '50s—made to show a cynical falsification of history. And, naturally, it caused bitterness among the artists, men and women both, who knew they should have been included on a purely historical basis. If the show had had another title, indicating it was simply one curator's choice of favorite artists, nobody would have had a beef. You can't argue with someone's taste. The Whitney annuals, for instance. It's ridiculous for women to demand to be included on the basis of some kind of democratic procedure or statistics. It's like saying: "You're including more Jewish artists than Italian; therefore you're being unfair to Italian artists." Or what about Gay Lib? Are they being adequately represented?

R: I don't think it's ridiculous for women to demand that

they be represented in equal numbers at the Whitney. You have to start somewhere.

E: Well, then the percentage is probably wrong. In shows selected by artists where there is no consciousness of sex, as in the American Abstract Artist shows which began in the late 1930s or the Artists Annuals of the early 1950s, the ratio seemed to be between one-third and one-quarter women. The only way to arrive at a true ratio, I suppose, would again be to have artist-juried shows.

If the Whitney leaves out a lot of women, so did Ms. Nochlin. It's been my experience that a lack of recognition of the creative endeavors of women is much more common among women than men. I think the writer here is indoctrinated by the very attitudes she's talking against when she says that "women, despite so many years of near equality, have still not achieved anything of major significance in the visual arts." As an art historian, presumably familiar with the scene, she should have had a much longer lineup of contemporary women artists.

I don't think that I'm over-praising anyone if I bring up Joan Mitchell, Marisol, Alice Neel, Jeanne Reynal, Grace Hartigan, Nell Blaine, Mary Frank, Jane Wilson, Jane Freilicher, Marcia Marcus, Louisa Matthiasdottir—or Dorothy Dehner, Anne Ryan, I. Rice Pereira, Isabel Bishop, Loren MacIver . . .

R: There are a lot more names: Fay Lansner, Alice Baber, Chryssa, Martha Edelheit, and we're still leaving some important ones out. Why don't we just make up a list of artists and hand it in and forget about this whole thing.

E: That was my inclination. But to go on. Ms. Nochlin believes that it is not very realistic to hope that a majority of men, in the arts or in other fields, will soon decide that it is actually in their own best interest to grant total equality to women. There's no such thing as equality in the arts,

and as far as I'm concerned, nobody had to grant me anything to become an artist, except for my mother. And now that I think of it, most of the creative people I know seem to have been triggered by their mothers—Bill, Franz Kline, Arshile Gorky, Jackson Pollock, Frank O'Hara—most of the artists and poets have swapped their "mother-stories." The author stresses the fact that in the past, a large number of artists—and almost all women artists—had artist fathers.

R: Well, things change. Out of hundreds of artists I know, I can think of only two or three that have parents that are artists—Mimi Gross, March Avery . . .

E: Jimmy Ernst, Anne Poor, Emily Mason, Mercedes Matter, Michael Nevelson—that's five fathers and two mothers, a likely percentage. But let's put aside the "field of art" and the "majority of men" for a minute and talk about those "other fields" and the real majority of women. Women have had the vote for over fifty years. Where are the women in elective office? Women could have put them there. Who needs to grant what to whom?

R: I just read in the *New York Post* that at the U.N., supposedly a showcase for equal rights, there are no women in the top echelons of the secretariat, no women undersecretaries, assistant secretaries-general or officers of equivalent rank.

E: I agree when Ms. Nochlin says "women's experience and situation in society, and hence as artists, is different from men's," except for the "hence as artists." Thirty years ago, the name of an article like this could have been "Where Are the Great American Artists." Museum directors, art historians, collectors, dealers, all acted as though American artists didn't exist. They were buying and exhibiting European artists (fortunately for New York artists, who got access to a quantity and variety of art unavailable in any other city in the world; I met Dubuffet in 1950 and he

told me he never saw a painting by Paul Klee in Paris until after 1948). Actually, the "liberation" of the American artist was accomplished largely by women dealers. Peggy Guggenheim opened her Art of This Century Gallery in 1942 and was showing Frederick Kiesler (he designed the gallery for her), Jackson Pollock, Robert de Niro, Robert Motherwell; Marian Willard showed David Smith, Tobey, and Morris Graves; Edith Halpert at the Downtown Gallery showed Stuart Davis, Zorach, and Ben Shahn; Betty Parsons had Hans Hofmann, Jackson Pollock, Barnett Newman, Hedda Sterne, Mark Rothko, Lee Krasner, Ad Reinhardt. And there were others: Rose Fried, Bertha Schaefer . . . The big-time galleries which came along and scooped up the proceeds—Janis, Castelli, Marlborough, Knoedler's, etc.—didn't show any interest until the reputations were made.

R: And Mary Cassatt had a great influence on the taste of American collectors; she advised people to buy El Greco, Goya, Manet and Degas, to name a few. Museum collections are enriched because of her exceptional appreciation of what was "good" and important. Her reputation in this matter should be above Bernard Berenson's. And, of course, she was herself a great artist—not just a critic.

E: And what about Gertrude Stein, the greatest discoverer of them all? I find artists are always generous to other artists. Jeanne Reynal bought Gorky, de Kooning, Noguchi, Rothko before any museum—when they were broke and needed the money. The first paintings Bill sold were to artists and poets: Edwin Denby, Allen Tate, Rudy Burckhardt, Biala and Alain, Saul Steinberg—and Saul bought Richard Lindner before the collectors got to him. In fact, most of the artists I know own other artists' work.

R: Yes, another artist's response is very important. I remember how much it meant to me when David Smith

came to my first show at a small downtown gallery in 1960 and told me he loved my work. He said, "Don't give up sculpture; I've known women sculptors and they stop; don't stop." I feel sort of guilty now because I turned to painting and writing.

E: But you didn't stop. One reason is that you were working in New York surrounded by fellow artists. I think what can make an artist stop is total neglect. And I don't think that's ever the case for artists—men or women—in major cities. In this country, it's not the woman artist who is neglected but the "out-of-towner." In '57, when I was teaching at the University of New Mexico in Albuquerque, I met a brilliant young painter, Joan Oppenheimer, who had been working there in isolation for some eight years after graduation. A seventy-five-year-old artist, Raymond Jonson, who had and, I hope, still has a gallery there, asked her to have a show. Both he and she knew practically nobody would come to it. "But," she said, "the brush was beginning to fall out of my hand until he asked me." Raymond Jonson himself seems to have Emily Dickinson's attitude. He is an excellent artist who has amassed an enormous amount of work which he just stacks away for a few people to view now and then. Artists like these are hidden away all over the country (and not clamoring for representation at the Whitney). I met two wonderful artists a couple of years ago in Missoula, Montana—Len Nye, who works as a bartender to support himself and his fantastic photography—close-up portraits of ranchers and winter landscapes that look like Japanese watercolors— and Don Bunse, who makes intaglio prints. Or in Pittsburgh, which is as out-of-town as Missoula, as far as the New York PR system is concerned, there are some terrific artists—Connie Fox, Marie Kelly, Douglas Pickering, Walter Groer; Lee Hall in Madison, N.J., and Marie Meinke in

Eugene, Oregon—they're all over. I'm astonished that these artists can keep going in the face of overpowering neglect —that they retain the art impulse.

R: When did you first have the art impulse?

E: When I was five years old, my mother took me to the Metropolitan. I remember being overwhelmed by the hush —the glamor of the place. Also I used to be mesmerized by the stained-glass windows in church—but it never occurred to me that anyone *made* them. I thought they were just *there*, like trees, chairs, houses, and the reproductions on the walls at home. I was always drawing, but I didn't make any connection. Then, by the time I was ten or eleven, other kids were asking me for my drawings and were referring to me as an artist. I hadn't given the matter any thought. I just loved to draw. I loved the activity. But when they bestowed the title on me (by then I was reading about artists and going to museums on my own), I thought, oh yes, I'm an artist, and from then on I took it for granted —and I began to compete. I'd read that Raphael had done something by the age of twelve and I'd get very anxious. I became very time-conscious. If I read about someone's great accomplishment at the age of twenty, I'd heave a sigh of relief and feel, maybe there's still time. How did you start?

R: Well, I got started through Sherman. He was a painter, but he had to work to support us. Rachel was eight years old. This was in Berkeley in '54. He had a job at the Rockefeller mouse laboratory where they had the cleanest mice in the world. He had to go through a decontamination area to get in and out. He would feel sorry for the mice and would overfeed them, like a Jewish mother, and then he had to clean the cages like crazy. At that time, I would go to city dumps and collect all sorts of rusty objects which I loved, and I made a rusty flower

garden in my house, odd shapes in vases, and I invited people to my home to see my beautiful garden. There was a museum of very old pottery at the University at Berkeley, and I wanted to have my own museum so I had to create all my own art. I wasn't aware of the art world then or of other artists. My very first art experience was actually coloring books which my mother brought me to occupy myself with when I was ill. I loved to color. I didn't think of myself as an artist. I was a kid who tried to make a beautiful picture. I had a girl friend, Ray, whom I considered to be a "real" artist. She did something I had not thought of: she put an outline in a contrasting color around the objects in the picture. This impressed me. We were poor. It was around the time of the Depression. We owned no art, no books. But a newspaper offered for a few cents, and a coupon, reproductions of famous paintings. My mother sent for a Turner seascape, a Rembrandt self-portrait, and a Vermeer. This was the first great art I had ever seen. Then, when we were married, Sherman took me to the Museum of Modern Art. I remember Rousseau's *Sleeping Gypsy* and the Matisse *Blue Window* and Léger. I was impressed but it was upsetting. I was indignant too. I remember arguing with Sherman about a Cézanne self-portrait. I thought it was ugly, awkward . . .

E: I think that negative response is often the way great art hooks us. I reacted to Cézanne almost the same way the first time I saw him when I was fourteen. Before then, I used to look at drawings in books and cartoons in newspapers. There was one artist I was mad about when I was ten. Her name was Nell Brinkley. She drew for the Hearst papers in the style—carried to unbelievably sugary extremes —of Aubrey Beardsley. I used to copy her endlessly. ·She had a technique of shading with very fine lines that fascinated me for years. I'd copy reproductions of Gains-

borough and Reynolds using Nell Brinkley's technique. Then I saw my first Cézanne and it jolted me. It was a *Bathers*. I didn't think he drew well at all. I thought the figures looked stiff and wooden, but I was enthralled by it. I knew there was something there that was going to take me a lifetime to understand. What I took to be the *crudity* of his technique—that opened a door for me. I began to look at everything. That was the year I discovered Matisse, Picasso, Degas, Soutine; I began to go to the Museum of Modern Art every week. At the same time, I loved *New Yorker* covers and El Greco. I didn't mind mixing things up. Nobody was going to tell me what to like or what not to like. Until I was seventeen I thought all real artists (I didn't count commercial artists) were dead or foreign, with the exceptions of Georgia O'Keeffe and John Marin, whose work I had seen at An American Place. I was overjoyed when I was taken to a show of the American Abstract Artists Group in '37. They were all alive and they were American! My escort further interested me when he told me the two best abstract artists in America were not in the show—Arshile Gorky and Willem de Kooning, whom I met a couple of months later when I began to study with him. When Ms. Nochlin says, "What is important is that women face up to the reality of their history," well, the point is, artists are always *choosing* their history from day to day and their history follows them as much as it precedes them. Were American artists "facing up to the reality of their history" when they turned to the School of Paris or to German Expressionism or Dada or Surrealism or de Stijl or the Bauhaus instead of to Copley, Peale, Eakins, Blake or Ryder; was Picasso facing up to the reality of his history when he went snooping around African art for inspiration?

R: And here, nineteenth-century artists, critics, and his-

torians come under attack for turning "the making of art into a substitute religion, the last bulwark of Higher Values in a materialistic world." Well, maybe we wouldn't put it in those words, but that's what art is all about as far as I'm concerned. There's a cross I made out of wood and rusty metal, hanging in St. Paul's chapel on Vesey Street in the financial district. People come and worship beneath it. It makes me feel very good. It was bought from my first show in 1960 and at the time, I couldn't believe that anyone else would want to own it. But I can understand it hanging in a church with all the gold and glitter and precious stained-glass windows. What has been discarded, used, thrown away, is still holy—if not holier. I think art and religion are very close—the spirit of reclamation and love.

E: And I'm all for the free enterprise conception of individual achievement.

R: That's the concept of genius that Ms. Nochlin seems to find threatening to women as part of a male plot, part of the "romantic, elitist, individual-glorifying and monograph-producing substructure upon which the profession of art history is based. . . ." Her main conclusion is that art is not a free, autonomous activity of a super-gifted individual influenced by previous artists, but that art is modified and determined by certain definable social institutions—whether art academies or systems of patronage—and her solution is that women should ". . . take part in the creation of institutions in which clear thought and true greatness are challenges open to anyone. . . ." Well the point is, I don't want to create any other institutions. I don't want to be *in* any institution.

E: I think there are too damn many institutions on the face of this earth as it is. Robert Graves said: "As soon as women organize themselves in the male way with so-

cieties, memberships and rules, everything goes wrong." I think that applies to artists, too. The artist stands for everything against institutions.

R: Institutions and clear thought are opposites. You can't have one with the other.

E: Right. Institution to me means authority, coercion, mindlessness, bureaucracy; it means the Pentagon, the CIA, the army, organized denominational religion, prisons, mental hospitals . . .

R: The only clear thought one can have in an institution is—how do I get out.

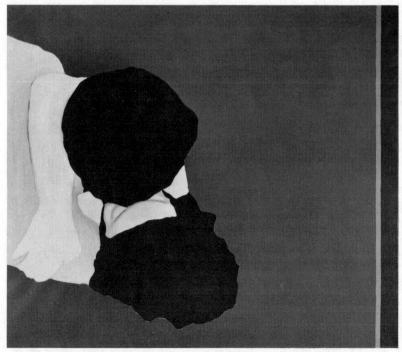

Rosalyn Drexler: *Embrace*, 1964, 50 inches high.

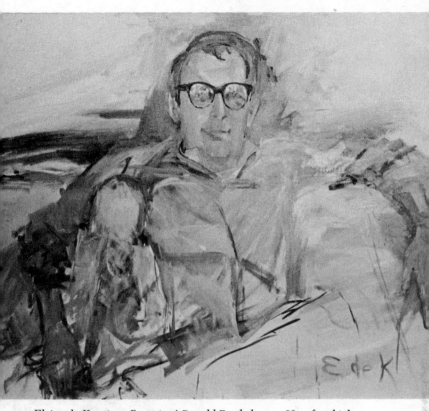

Elaine de Kooning: *Portrait of Donald Barthelme,* 1968, 4 feet high.

Loren MacIver: *Taxi,*
1952, 48 inches high.
Wadsworth Atheneum,
Hartford, Conn.

Alice Neel: *Gerard Ma-
langa,* 1969, 60 inches
high.

Kay Sage: *Three Thousand Miles to the Point of Beginning*, 1947.

Chryssa: *Study for the Gates to Times Square, 4,* 1966–67, 43 inches high.

Mary Frank: *Leda*, 1963–64, elm wood, 25 inches high.

Perle Fine: *Hot Slash of Blue*, 1967, acrylic on wood collage, 50 inches square.

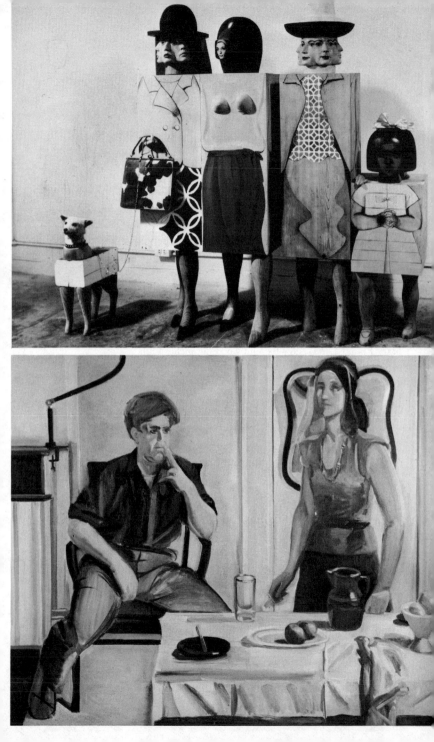

(ABOVE)
I. Rice Pereira: *Undulating Arrangement,* 1947, 23⅜ inches high.
Wadsworth Atheneum, Hartford, Conn.

(ABOVE, LEFT)
Marisol (Escobar): *Women and Dog,* 1964, wood, plaster, synthetic
polymer, 6 feet high. Whitney Museum, New York.

(BELOW, LEFT)
Louisa Matthiasdottir: *Portrait of the Artist and Her Husband,* 1968, 52
inches high.

Louise Bourgeois: *Noir Veiné*, 1968, marble, 23 inches high.
Knoedler, New York.

Jean Follett: *Many-Headed Creature, 7*, 1958, relief, sand,
wire and rope on wood, 24 inches square.

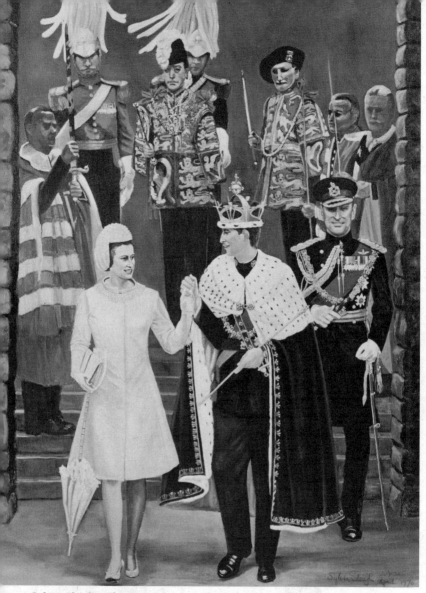

Sylvia Sleigh: *The Investiture of Charles, Prince of Wales,* 1970,
60 inches high.

Charmion von Wiegand: *Transfiguration*, 1958–60, 42 inches high.

Marcia Marcus: *Frieze: The Studio,* 1964, 77 inches high.

THE HERMAPHRODITE

By
Bridget Riley

Bridget Riley, one of England's best-known painters, won the International Prize for painting at the Venice Biennale in 1968; a retrospective of her work toured Europe in the spring and summer of 1971.

It has long been established that both male and female psychological patterns are present in all of us, in differing degrees, and that simple biological differentiation offers us a concept of the whole matter that is both incomplete and inadequate.

It seems to me that in many cases the richer the personality the more harmoniously present is this duality. The artist, in particular, draws upon it quite naturally while working; the artist could almost, in fact, be said to be a hermaphrodite at such times.

In the act of love, physical differentiation establishes polarities which, when resolved, lead in principle to the birth of a child. This structure would appear to find its parallel in the indispensable dialogue between the artist and the work-medium. And those polarities can likewise result in the creation of art.

I have never been conscious of my own femininity, as such, while in the studio. Nor do I believe that male artists are aware of an exclusive masculinity while they are at work—not even Renoir, who is supposed to have said that he painted his paintings with his prick. (I should interpret

this remark as expressing his attitude to his work as a celebration of life.)

For the artist who is also a woman, I would not deny that society presents particular circumstantial problems. But in my opinion these are on the wane, and in any case, few male artists have avoided analogous sociological problems of one sort or another: for example, poverty, unsympathetic marriages, alcoholism, geographical isolation, illness, etc.

Women's Liberation, when applied to artists, seems to me to be a naïve concept. It raises issues which in this context are quite absurd. At this point in time, artists who happen to be women need this particular form of hysteria like they need a hole in the head.

DO YOUR WORK

By
Louise Nevelson

Louise Nevelson, one of the most famous American
sculptors, began her well-known monochrome wood
wall-environments in the late 1950s. Her work was the
subject of a 1967 retrospective at the Whitney Museum.
She showed more recent works there in 1970 and con-
tinues to exhibit actively in New York and elsewhere.

Linda Nochlin equates the feminists' misconception of
what art is "with the naïve idea that art is the direct, per-
sonal expression of individual experience . . ." Then she
goes on to say what "great art" is—"The making of art
involves a self-consistent language of form . . ."

I believe both statements to be oversimplified. Emotion
and intellect are integrated. Human beings are heir to all
emotions. The basic work of creation is emotional and
reflects the depths of humanity.

When we come on earth, we come with the equipment
of awareness. In a given moment we can encompass the
whole past and project into the future and that is the com-
mon denominator of humanity.

The world has thought up to now in "male" vocabulary.
Now I think the door has opened. The level of awareness
has increased in woman so naturally she will have to, by
her very nature, hit heights of creativity that have been
closed to her before.

Single-mindedness, concentration and absorption in one's
work come through the unfolding of the individual's self-

development and should not have anything to do with "masculine-feminine" labels.

If you have something to say, you develop a means, a structure by which to unfold. If the creativity is there, the impulse to do your work or art naturally finds its own unique order and is stamped by the particular artist and that is art.

People unfortunately have been plagued by guilts and frustrations from the beginning. But if we have insight, and recognize the forces that have subjected us, we can pass that stage.

In my case, I had no uncertainty or lack of conviction as far as art was concerned. That is my life. Society, personalities, and problems are quite another story.

The whole slant of this article is a personal interpretation of the nature of art and the so-called nature of women. And to comment further in depth would mean a line-by-line analysis, and that of course would interrupt my art.

WOMEN WITHOUT PATHOS

By
Eleanor Antin

Eleanor Antin is a New York conceptual artist presently
living in California. She has had several exhibitions in and
around New York, and is currently producing a serialized,
mail-distributed "conceptual novel," concerning the pho-
tographed adventures of *100 Boots*.

I agree with Linda Nochlin that the question "Why have
there been no great women artists?" is a useless one and
that there are very real questions to be considered about
the relation of women to the arts. Just now I consider my-
self something of an authority on the position of women
as subject matter, having recently mounted a show of object
biographies called "Portraits of Eight New York Women."
I think my experiences with that show have some relevance
to the discussion.

The show was conceived from the beginning as an
argument against Flaubert, Tolstoi, Dostoyevski, etc. With
the exception of Defoe and Ibsen, we have always been
losers. It has been part of woman's glamor as an artistic
subject that she was seen as pathetic, passive—in short,
the superb victim. Most artists are gentlemen and treat us
with compassion—liberals are always compassionate—but
their verdict is inexorable. Anna Karenina doesn't leave
her up-tight husband to become commissioner of railroads.
She leaves only when she finds another host to live off.

Tolstoi calls that bizarre practicality a romantic nature. Flaubert may say he is Madame Bovary, but *she* never locked herself into a room to write unpopular novels or went to court to defend them. I was determined to present women without pathos or helplessness. Since a life style is the ability to recognize in the morning the same person who went to bed at night, it can be said to be a person's most important decision. My women had all chosen life styles independent of men's. It is true that some life styles proved more successful in practice than others, but they were all interesting and complex enough to be worth the try. Finally I deliberately chose styles whose linguistic structures were ambiguous, because a puzzle is harder to love than a fact.

My sculpture is made of brand-new American manufactured consumer goods. In my previous show ("California Lives") the portraits were done with objects purchased in discount centers. California *is* pathetic. It is Nixon's world, lethal and very sad. I listened to Jeannie Seeley records for months while doing the show. And all my Californians were pathetic, men as well as women. I suppose one might say I was democratic in this. As in Chekhov. They all sat around while the redwoods fell down. For "Portraits of Eight New York Women" I deliberately chose expensive, shiny, glamorous objects. I chose bright colors, reds and pinks. And as much chrome as possible. I didn't want the viewer to come too close. We women have had enough love. Frank O'Hara said once that he loved Marilyn Monroe. Protect us from such love! If Monroe hadn't had yellow teeth or if her body hadn't been deformed, would he have loved her then?

THE DOUBLE-BIND

By
Suzi Gablik

Suzi Gablik is a painter and writer who has shown
frequently in New York, most recently in spring 1972.
She has written numerous critical articles and has pub-
lished a book on Magritte.

I used to reel back in horror at the tactics of women who
burn bras, claim in WITCH and SCUM manifestos that
men are "unfit even for stud service," and introduce raw
eggs and Tampax inscribed with messages about "equal
rights" into museum galleries. I never really thought of
women as victims of a mysterious fatality. Like Simone de
Beauvoir, I refused to conclude that their ovaries condemn
them to live forever on their knees. I believed that personal
creditability was achieved by acid intelligence, enlightened
will, and superior effort. Since I never subscribed to the
mystique of motherhood or to the cult of routine domes-
ticity, I found myself by my middle thirties in the priv-
ileged position of being able to do largely as I pleased.
Nevertheless, I have always been uneasy in an amorphous
and unfocused way about the relatively small role of
women in world history, and plagued by the seemingly
unaccountable lack of first-rate women artists. I have al-
ways assumed that this arose from the collusion which
women often practice by sacrificing aspects of their identity
and development in return for "security" and the fulfill-
ment of a stereotyped idea of femininity. From the begin-
ning women face a conflict of roles which men by and

large are spared: they are deluded into thinking that dependence and subordination offer inbuilt rewards. That attitude is moreover authorized and encouraged by the society in which they live, and it is reinforced still further by the notion that womanhood remains incomplete and thwarted without a child.

But there is much more to it, I now realize, than these various forms of self-enchantment on the part of women. Society puts them in a double-bind from the start. An unmarried woman is regarded as a disadvantaged person, and her self-confidence is undermined. If, on the other hand, she follows her stereotyped role and limits herself to being a wife and mother, the echoes of male disparagement will haunt her: "It seems that women have made few contributions to the discoveries and inventions in the history of civilization" (Freud). Or, "Women have in general no love of any art; they have no proper knowledge of any; and they have no genius" (Rousseau). Should she strike out on her own and refuse to enter into the sexual bargain, she is once again subject to masculine contempt: "A man . . . must always think about woman as Orientals do . . . as a possession, as a property that can be locked, as something predestined for service and achieving her perfection in that" (Nietzsche). In general, men suspect women who choose to make their own way, and so do other women.

Certainly the field of human actions tends to operate in probabilistic terms. However, those persons who develop an awareness of the factors which are conditioning them at any given time have the possibility of de-structuring the field and switching their conduct from the expected channels. In this reflective self-awareness lies the promise of an indispensable change in our culture, which until now has been saturated in assumptions, both conscious and unconscious, of male superiority.

HEALTHY SELF-LOVE

By
SYLVIA STONE

Sylvia Stone is a New York sculptor who has had numerous one-woman exhibitions. She is on the faculty of Brooklyn College.

At a recent meeting of women artists, they agreed that they had all "come out of the closet." What a relief. The new camaraderie between women has led to a support and concern for one another's work, life interests, and conflicts. Everywhere I go I meet interesting women; the point is, they were always there, but often too busy playing the nonperson role to make themselves felt as individuals and artists.

Many of the women who have enjoyed the rarefied atmosphere of professional acceptance have prided themselves on making it in a man's world, and they see little reason to support the drive for equality for women. There may have even been a sneaking fear of being called a man-hater, or having the label of penis-envy slapped on them in this Freudian age, or perhaps they just enjoyed being "one of the boys." But these feelings are slowly turning around—an awareness, perhaps, that they have enjoyed their exclusivity at the expense of their sex. (On the occasion of the 1971 Whitney Sculpture Annual, more than one person told me that it was too bad that so many women had been included because it might detract from any attention that I might receive as a woman artist. What artist would want to be judged by such criteria?)

Though I've experienced prejudice as a woman artist, I've also received encouragement. My male colleagues helped to appoint me to a professorship in the City University on the basis of my work and teaching. Men, definitely not women, have been responsible for gallery and museum exhibitions of my work, but I'm quite aware of the quota system for women in galleries. God forbid that they should have "a gallery full of women." It naturally follows that fewer women artists are exposed to museum curators, writers, architects, and collectors. Though we can climb up on our pedestals and claim that that's not what making art is all about, we know that an anonymous existence corrodes the spirit and independence of the woman artist. She's hardly adapted to playing the "unknown genius." However, most women are pretty realistic about the lack-of-recognition syndrome. Women frequently give up, too, because society has not found a woman's work (outside the home) central to her identity. It *is* central to the male identity—and becomes so, I've observed, by the time a boy is five years old.

Emphasizing and reemphasizing the problem has made us all aware of the predicament of women in the visual arts, and in many other creative areas, for that matter. One must deal with it realistically in terms of self-action. Railing against the male oppressor only provides temporary satisfaction and wastes a lot of energy. Instead of hating men, I think I'd rather start loving women, and loving myself in the process. Healthy self-love and independence makes one question the male-establishment point of view we always have lived by: their view of what is great art, great women, a great society. The way out is a desire to take responsibility for the structure of society and the responsibility for the restructuring of ourselves.

It should be a natural event, then, to see the blooming of women as artists, creating art of their time, free to make

MOVING OUT, MOVING UP

By
MARJORIE STRIDER

Marjorie Strider is a sculptor who developed out of Pop painting in the early '60s into her current mixed-media illusionistic constructions. She has also been active in Street Works and other types of performance pieces. She recently had a one-woman exhibition in New York.

On Being an Artist—or—The Artist as Being Great

Being: Existence; conscious existence. That which exists as an actuality or entity in time or space, in idea or matter. The fullness of life or perfection to a thing that exists.

Great: Large, big. Being much above the average in magnitude, intensity, importance, etc.

My History as Artist and Being Great

Endo, ecto . . . out into and back again . . . from painting to sculpture to performance, out from the wall into solid matter . . . out from manipulating materials, into manipulating living bodies . . . going from using illusionary space into actual space . . . going from stop-motion on a stationary surface to motion of materials, materials for motion

being water, urethane foam, people . . . everything a movement from the wall to the middle of the room and back again . . . a breaking out, a flowing . . . to make round and flatten out again . . . motion existing in going from fullness to fractional and back again . . . eventually, for the perfection or fullness of life, a synthesis of things . . . painting, sculpture, performance, no longer designating division, but everything coalesced into one moving entity.

Anyone's History as Artist and Being Great

From physical labor to headwork, to being in touch with oneself and back again . . . communication and idea exchange, intellect, emotion and conversation . . . breaking barriers, committing oneself, being involved . . . from being a man to being a woman, and moving in between . . . from being a child, to growing knowledgeable and returning to simplicity . . . from being free to being restricted, to being sovereign . . . from breaking out of restrictions in art to breaking out of restrictions in society . . . from being to art and it's all the same . . . being, artists, male, female, sculpture, painting, performance, all conjoined in a great motion.

A Woman's History as Artist and Being Great

Out from underneath to the outside . . . from being thought odd to being realized . . . from being an object to being a being . . . from great effort forced out to breaking out with ease . . . from not participating in political

tactics to doing it with great work . . . from not sensitizing the public with cries of male chauvinism to blasting the public with terrific sculpture . . . out from subservience to serving and being served . . . from being whistled at on the street to doing the whistling yourself . . . out from society's disapproval to your own approval is all that matters . . . out from need of escorts to going anywhere . . . out from sex as a barter system to sex as pure enjoyment . . . out from being unable to support yourself to teaching other artists . . . going out with society as it becomes more free into women being a part of that freedom . . . out from feeling maligned by society's restrictions to feeling joy at being able to break barriers . . . out from being one of a few into being the best of many . . . to break through being a woman with the only proof that you are equal— great work, great intellect . . . from being set free by certain aspects of women's liberation to disagreeing with most tactics being used . . . out from under being a woman into pride at being a woman . . . out from under "I thought a man did it" to it doesn't make any difference who did it . . . from being dainty and delicate to being what you are . . . from difficulties with society's disapproval with the way you live your life to realizing it extends over into being an artist . . . from realizing that some men are oppressed to realizing it's all becoming easier . . . from ignoring the facts so that you can do your work to being able to admit them and still come through . . . from being small to being large and always moving only out and up . . . the motion being one huge expansion.

SOCIAL CONDITIONS
CAN CHANGE

By
Lynda Benglis

Lynda Benglis is a sculptor who has participated in group
and one-woman exhibitions in New York, around the
U.S., and in Germany.

A person's identity is a composite picture of one's ideas,
beliefs, infinite longings, abstractions, glances in mirrors,
personal relationships, size, height, weight, and color; one's
library card, driver's license, social security number, bank
account, acquired names; one's occupying one space as
opposed to another, one's wearing of certain clothes as op-
posed to others, one's taste in food, one's sex.

How am I to simplify the composite picture "female"
and "artist" in words? There is not a doubt in my mind
that we still exist in a very self-conscious, sexually-
repressed time. Although our culture has been and is male-
dominated, the sexual experience is not unique to males
nor is the art experience unique to males. Different organs
and physical responses do not necessarily preclude females
from the activity of art.

I feel that art is an intellectual process which both ques-
tions and affirms the very nature of being. My concerns of
identity within and outside the confines of my studio or
working situation have everything to do with my experi-
ence. And my experience is primarily that of an artist and
I am a female.

I agree that the presence of few female artists in the past is very much a social condition, not an esthetic one. That the social condition can indeed change—that it will change because the desire of female artists to exhibit their works is a necessity; simply because there are more females choosing to do art.

With the present-day consciousness-raising on the part of feminists, I understand the need to give a kind of historical perspective to female artists. Within this kind of female-consciousness, it is possible for more women who are in the art world to give justified attention to those current works they find challenging. Continuing consciousness-raising may depend upon mutual recognition by woman artists and the extent to which they take on the responsibility of transforming the present role situation.

Both men and women are at fault in the present social dilemma, *viz.*, the necessity to declare oneself female and artist in the same breath. If there were more female artists, and that will depend upon their effectiveness as examples, the term "artist" would no longer imply one sex only.

ARTISTS TRANSGRESS

ALL BOUNDARIES

By
Rosemarie Castoro

Rosemarie Castoro is a New York painter who has also
done work of a quasi-conceptual nature involving space,
light, and perception. Her room with light-bulb piece
was seen in Vancouver and Düsseldorf; she recently had
her second one-woman exhibition in New York.

What does an artist want? Exposure. Something snaps our
vision. The Body responds with production.

"Castoro, Castoro, I saw your paintings at Johnny's. I
liked them very much. I thought you were a boy."

I turned around and went back to Spring Street, pro-
ducing my next body of work. My energies in the world
were for those not yet born. I laminated myself against
the walls with my paintings. Cézanne didn't live on insti-
tutional acceptance. Time validates and invalidates. What
turns you on? Doing turns me on.

I became hostile. It kept me working. I finally isolated
myself, climbing the walls in my studio, snarling at who-
ever crossed my path. I moved ceilings, cracked rooms,
dumped paint in the streets. I went to Vancouver to build
a 15-foot-square room lit with one 4-minute rheostated
light bulb.

Upon returning to my studio, I moved into the middle of
the room, gave up the straight-edge, and released my

energies onto hard surfaces which are growing into curved, free-standing, portable walls.

I think artists transgress all boundaries and should not be segregated according to the comfortable academic niches supplied by curators, let alone by society. Man, woman, black, white, big tits, big penises, Italian, Jewish. Every artist is something. I didn't become an artist because there was a job vacancy. My altruism is for those who have already decided on who and what they are.

Suzi Gablik: No. 2 from *Tropisms* series, 1970, 2 feet high. Dintenfass Gallery, New York.

Sylvia Stone: Untitled, 1971, plexiglass, 39 inches high.

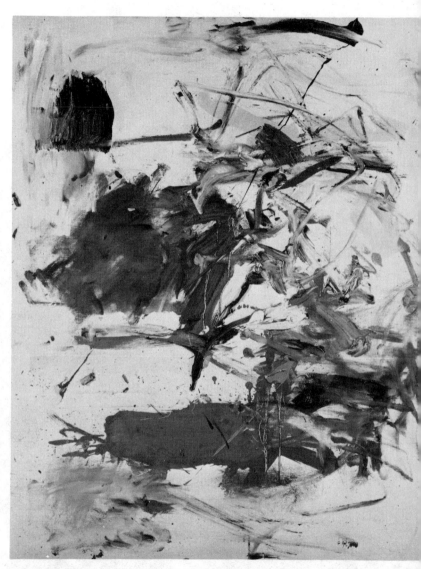

Joan Mitchell: Untitled, 1960, 36 inches high.

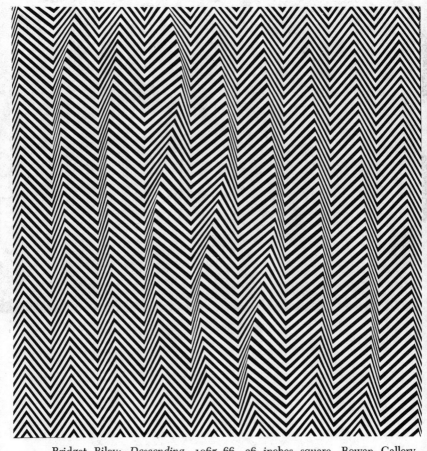

Bridget Riley: *Descending*, 1965–66, 36 inches square. Rowan Gallery, London.

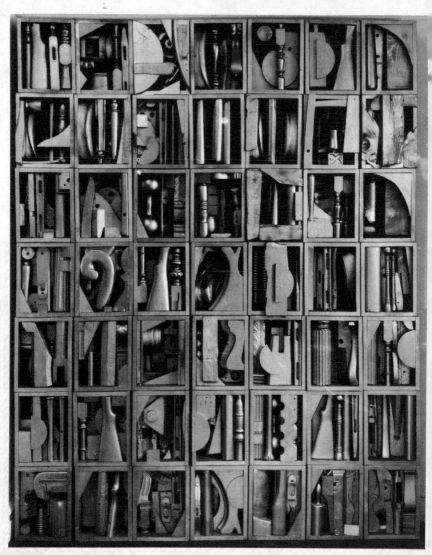

Louise Nevelson: *Dawn,* 1962, painted gold wood, 94½ inches high. Pace Gallery, New York.

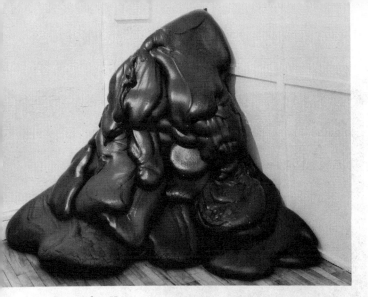

Lynda Benglis: Untitled, 1970, pigmented foam, 5 feet high. Paula Cooper Gallery, New York.

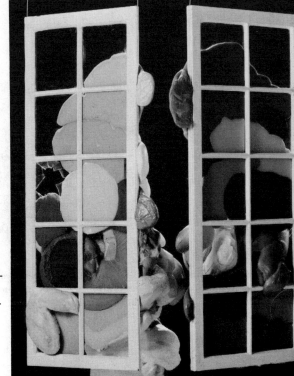

Marjorie Strider: *Window Work 1*, 1970, pigmented foam, shattered French doors, 4½ feet high.

Eleanor Antin: *Portrait of Naomi Dash*, 1970, monogrammed towel, chrome bar, shower cap, tights, kitty litter in pan.

Rosemarie Castoro: *Break in the Middle,* 1970, graphite on gesso panels, 7 feet high. De Nagy Gallery, New York.

SEXUAL ART-POLITICS

By
Elizabeth C. Baker

There are increasingly vociferous and organized protests from women artists that things are neither fair nor square. Much of this feeling came into focus during the big 1970 Art Strike and subsequent related political and protest activities. An increasingly major target, in addition to war, racism, and repression, was sexism. Necessarily a fringe issue at the time of major upheavals such as the 1970 Cambodian invasion or the shootings at Kent State, the problematical situation of the woman artist has nevertheless come to be recognized as a full-blown *cause célèbre*. This began mainly through the efforts of a relatively small number of politically active art-world women—artists, critics, others—many of whom were already active in such organizations as the Art Workers Coalition and other manifestations of various strikes.

In the fall of 1970, for example, a group of them [1] demanded that the upcoming Whitney sculpture annual include fifty percent women. True, women did not make up half of the community of working artists. Yet it was felt that a quota would be a corrective to virtual neglect. Some of the tactics used against the Whitney when the museum predictably refused to adhere to any quota were extremely bizarre, and there were also a number of far-out manifestoes. [2] Since there has been and continues to be a certain air of unreality to many of these actions—which often goes along with the tendency for art-world

politics to resemble Happenings or conceptual art—it is well to remember the main point: that there is still serious discrimination against the woman artist.

Art-world discrimination does not fall into consistent patterns and is not always either conscious or deliberate; it has not prevented a conspicuous number of women artists from sustaining productive and successful careers. Yet today, at a time which is characterized by its self-awareness and often by its good intentions about such matters, at a time when there are more women artists and more successful ones than ever before, the protests are coming with ever-increasing urgency. What exactly is the plight of the woman artist all about?

The question is a complicated one. There is still a broad social climate in which (despite decades of "emancipation") women are not encouraged or motivated to take their work seriously. Most women do not even consider seeking professional jobs. This is too large a matter to deal with here, but it is one major factor which keeps the number of serious women artists relatively low.

It is obvious that getting started as an artist is difficult enough for men. But the burdens inherent to surviving in a lonely, demanding, and capricious profession fall with particularly destructive weight on women. The roadblocks they face can be overwhelming, especially to the early, shaky stages of a career. Women artists also face a set of special dilemmas. When young male artists are granted the benefit of the doubt, though their work may be immature or undeveloped, women artists frequently have to persist in a unique kind of isolation. A notably painful case can be when two artists marry, and the world assumes that the husband is the only serious one of the pair. Career conflicts are not infrequent. Marriage and work are not mutually exclusive for men, but for women the alternatives

often evolve into an either/or choice. This is the point at which many talented women artists stop working.

More specifically, the problems of the woman artist break down into three main categories: preparing to be an artist, earning a living, and gaining recognition.

Linda Nochlin's contribution to this volume points out that in the nineteenth century and earlier, pervasive, even "automatic" institutional barriers were established which cut women off from essential professional training; thus even those who were determined and motivated were prevented from attempting to reach the higher levels of competence. Today this is largely changed. Art schools everywhere are more than half full of girls. Furthermore, there is no longer just one single road to becoming an artist; anyone near an active art-making center can have access to the broad sources of today's art.

While it is no longer difficult for a woman to train to be an artist, one has only to look around to realize that genuine obstacles stand in the way of her further pursuit of a serious career. Once she is past art school, all sorts of difficulties appear and multiply. The problem of how an artist is to make money when work isn't selling has always been a knotty one. However in recent years various kinds of flexible teaching appointments which pay comparatively well and may occupy only a part of the year, or grants of various sorts, have started to fill that gap. Women artists have not received a reasonable share of these jobs or grants. The professional art schools, as well as those in the universities, while they do not officially exclude women faculty members, give decisive preference to men. Most of the fifty-percent-plus female art students now in the schools, if they end up making a living by teaching—and many of them do—find their jobs at the high-school level or below. (The small number of women they had as teachers may convey the message that it is not realistic to aim

too high.) The proportion of women on New York art school faculties is minuscule.[3] There are, too, for those few women who are taken on, subtle and anachronistic job hierarchies which are disparaging by implication: often women are allowed to teach how to draw but not how to paint, etc. In addition they are often hired in a peripheral capacity, perhaps as a last-minute fill-in, often not given full pay or tenure. They are, when hired at all, generally "cheaper." Some schools still bar qualified wives from teaching where their husbands do. While this situation has changed somewhat in the last couple of years, under pressure of various equal opportunity laws, it is still much more difficult for a woman to get a job which has some relation to her own work as an artist, than it is for a man.[4]

Showing work, gaining recognition, establishing a reputation are the most nebulous, the most ambiguous, the touchiest objectives. It is here that the woman artist who hustles her work (not herself) in an enterprising manner is accused of being excessively ambitious and aggressive. It is likely to be said that the ambitious woman artist is unbecomingly concerned with "commercial" proofs of success. It is also in this context that she is most frequently faced with the "explanation" for a difficult-to-breach status quo: ostensibly, that those women who are good enough do get ahead. The others don't, and don't deserve to, and any attempt to improve their position is an attack on "quality" in art.

It is obvious that good art has no sex. Women artists themselves are the first to assert this. Even so, dealers are rarely impartial about the sex of their artists. Many major galleries tend consciously to hold down the number of women artists they represent.[5] Certain galleries (several of New York's major avant-garde ones are conspicuous here) virtually—whether by design or not—exclude women. One

well-known woman dealer has said openly that she will
never take on a woman artist in her gallery; she says
women "are not as good."

Does this translate, "women's art doesn't sell as well"?
The question is elusive. No surveys have been made, and to
do so would involve delicate correspondences between
male and female artists of "equal" quality, stature, pro-
ductivity, style, etc.—impossible correspondences, of course,
to pin down. While the general expectation is that women's
art does not sell as well, it is not entirely clear that this
is the case. But as long as it is the expectation, it may as
well be the case, at least in terms of perpetuating dealers'
prejudices. There have always been isolated cases of great
worldly success among women artists. Today, one thinks
of Louise Nevelson and Marisol—both have something of a
separate existence as celebrities—as examples of women
whose work has been in as much demand as men's. But they
are exceptions.[6]

Finally, while statistics which might clarify these pat-
terns are not available, it is obvious that museums are
less ready to support young women artists than young men.
Women artists generally have to be extraordinarily well-
established before being bought for collections, or given
major exhibitions.[7]

It has often been noted that the art establishment is far
from consistently male. Dealers are frequently women
(influential ones have included Peggy Guggenheim, Betty
Parsons, Martha Jackson and, more recently, Virginia Dwan,
Eleanor Poindexter, Marilyn Fischbach, Paula Cooper.)
Many critics are women. Even that rigidly stratified male-
chauvinist preserve, the museum profession, is gradually
opening to qualified women. Yet most women who have
influence have not leapt to champion women artists. Gen-
erally their attitudes have been ambivalent. At the very

least, one can observe that the question of establishing a more balanced consideration of women's art has not until now presented itself as any particular objective. It is possible that as the arbitrariness of the imbalance becomes better known, the situation will improve. A conscious attempt to be even-handed need in no way carry implications of diluted critical standards.

When the Whitney sculpture annual opened in December 1970 with a representation of about twenty percent women artists—22 out of 103 sculptors invited to show. It represented something of a victory for the protesters: the preceding year's Whitney annual (which was a painting survey; there are more women painters than sculptors) had about five percent women.[8]

It is ironical that the Whitney Museum became the target for pressure tactics from women. All along, it has shown pronounced if erratic tendencies in favor of women. Its founder was a woman. It has given them more solo shows than any other New York museum. During the 1970–71 season, it held a special show of women artists in its permanent collection. Co-incidentally, there was a group of paintings by Lee Lozano on view at the same time. A large Nevelson show, as well as a major retrospective of Georgia O'Keeffe, were also highlights of the same winter and more recently there have been one-woman shows by Jane Kaufman, Susan Hall, and Chryssa.

However, the Whitney annual itself is a different kind of target. Despite constant disparagement, people go to see it. It has the important function of disseminating information (if not exactly conferring prestige). And especially for younger artists, it represents a goal of sorts—the more so for the reason that it is the only thing of the kind in New York.

So if the representation of women in the 1970 Whitney show suddenly shot up fourfold, what did that prove? That if you push museums hard enough, you get what you want? Or that there are plenty of good women artists, but they need political support before they can receive their due? Or, on the other hand, does such a shift betray, as some cynical observers have suggested, a surrender by the museum in the face of pressure and a consequent dilution of standards?

Some sort of compromise on grounds of expediency could perhaps be suspected on the basis of recent figures, if one actually believed that the museum had been genuinely doing its best before. But this is far from the case. It is not difficult to document that a substantial number of qualified women artists were being bypassed with inexorable regularity.

What is most surprising though, if one takes a slightly longer view, is that the peripheral inclusion of women in such events in recent years represents a puzzling loss of recognition. For in the 1930s and '40s, large group shows were likely to include from a quarter to a third women, as a matter of course. During the '30s and the '40s, too, women's careers in general were on the increase.

What happened, of course, is that the art world was subject to the same "counter-revolution," the same shift of attitude that resulted in the overwhelming retreat-to-the-home movement for American women following World War II. This was particularly strong during the '50s, for a number of reasons which have been lengthily documented, analyzed, and speculated about elsewhere (see Kate Millett, Betty Friedan, et al.). The only approved objective during that time for even the highly educated middle-class girl (most artists have middle-class backgrounds) was marriage. The devastating effects of this period obscured a

favorable view of women's accomplishments of earlier generations, leaving only the mythologically familiar "horrible example" of the frustrated, neurotic careerist. Such stereotypes (perpetuated not only by the media but by even the best schools) naturally affected the woman artist's stature as a professional, as well as her drive and self-esteem—as was the case with her counterparts in other fields.

The climate for women's careers was more favorable, or perhaps it would be more accurate to say less unfavorable in the 1930s, for a number of other reasons. One important factor was the prestige of the few women who had been (without any particular sexual fanfare) active participants in the heroic phases of the avant-garde—for example, Georgia O'Keeffe, Sonia Delaunay, Sophie Taeuber-Arp. Women such as these had consolidated some major accomplishments; the possibility of doing likewise was accorded their followers. In addition, pervasive liberal sentiments among '30s intellectuals incorporated a relatively evolved view of women.

Also different was the fact that in the '30s, many major group shows were juried by artists. Artists, despite competitiveness, tend to be generous toward each other, as well as comparatively objective and much more knowledgeable than any other group about the merits of work. Men artists have been consistently helpful to women of talent. More recently, however, large surveys have been put on mostly by museums, and the whole thing now has a more official air.

In the 1930s, '40s and well into the '50s, American art was not big business, either. In the early days, good art was made by a rather small number of people and was valued for itself. Whatever the gains which came with the maturing of American modern art, an undeniable side effect has been

its rampant commercialization. As its sale and promotion have become an extremely lucrative enterprise, the woman artist has been pushed aside. Whether or not women's art is really potentially less salable than men's, any discrepancies were irrelevant when men's work was not bringing much in the way of prices either. But when certain artists' works skyrocketed in the late 1950s, everything changed. The art world came under the sway of attitudes of the commercial world, which was never as impartial toward women as the relatively free and open art milieu.

(To over-simplify this progression, when art didn't sell, women had a more or less equal opportunity to show. When the majority of the art which began to sell was by men, women were slowly squeezed out, first from galleries, and then also from museums, since museums rely heavily on dealers. It is interesting to note that most American collectors are either women or advised by women. Therefore it could be claimed that the feminine mystique—i.e., that women should not be professionals—has operated through women buyers, against women artists. (Another peripheral point in this connection is that many of these same women collectors, in encouraging young artists, also like to engage them socially, preferably as "extra men.")

Thus the recent agitations which centered on the Whitney and which appear likely to continue are, in some respects, an effort to reclaim lost ground. Despite any sensation of *déjà vu*, this is an important objective. It is an old problem, but it isn't solved.

Nevertheless there is nothing resembling universal agreement among women artists that political-confrontation methods are the proper approach. To a number of them, there has been something slightly unsavory about the Whitney affair. For one thing, it has been unclear where

demands for fairness left off and a generalized and perhaps opportunistic antiestablishment blitz began. High-pitched styles borrowed from war protest, civil rights actions, etc., have seemed incongruous for a cause that is largely a question of self-fulfillment in circumstances which, while still obviously disadvantageous, contain possibilities reasonably conducive to survival.

Many also felt that the quota demand was fatal to any objective standard of quality, with its implications of special treatment.

But most important, women artists want recognition on their own. They are artists and individuals before anything else. Recognition of their work on merit is desired in the framework of all art.

Women artists today, despite problematical conditions, form a growing rank of professionals who are in the process of making their own individual contributions to a wide range of current styles. Works by contemporary women artists which are reproduced in this volume are only a general, and necessarily random indication of the breadth of what is being done.

Artists are an elite, women as well as men, and they choose their objectives freely. The overtones of martyrdom which dominated certain recent phases of art-world protest (not just that of women artists) hardly ring true. Lip service is already being paid to women's rights. The support of men artists, especially younger ones, can now be taken almost for granted. Women of substantial achievement now must develop their potential for major contributions into a consistent and unquestionable reality.

The full emergence of the talents of any group which suffers from unusual circumstances—and women artists, even with their successes to date taken into account, do fit this description—takes a long time. In view of the num-

ber of younger women artists who are doing excellent work, one can surmise that this current generation stands closer to producing more excellent women artists than ever before. We may be approaching the last phase of having to consider the accomplishment of women artists as a special case.

NOTES

1. Ad Hoc Women's Committee of Art Workers Coalition, WSABAL (Women Students and Artists for Black Artists Liberation) and Women Artists in Revolution (unfortunate acronym: WAR), along with many individuals.

2. For example, one from W.A.R. demanded 50 per cent female representation in all New York museums by 1973, with elaborately structured interim requirements for achieving this end.

3. One of the better records among New York art schools is that of the School of Visual Arts, with all of 5 women artists on its large Fine Arts faculty in 1971.

4. In a new angle of attack (for the art world), efforts are being made by women artists groups in conjunction with the city's Human Rights Commission to investigate legal steps which might be applicable in certain situations. Most crucial are proposals relevant to earning a living, and these are centering on the art schools.

5. A winter 1970–71 spot-check by telephone of ten galleries turned up 190 men and 18 women. The distribution was uneven. The galleries were ACA, Castelli, Dwan, Paula Cooper, Borgenicht, Marlborough, Bonino, Sachs, Wise, and Rubin. Borgenicht, Wise, Rubin, and Dwan represented zero women, Castelli, one.

6. That this discrepancy in demand and price also exists outside the purlieu of Serious Art was exposed some time ago in *Life:* it seems that Walter Keane, of the fabulously salable Keane-eyed crybabies, did not paint them at all; his divorced wife revealed that she was actually the art-maker in that household. But Walter promoted and sold the pictures under his own

name, assuming that if people thought they had been painted by a man, they would bring a higher price.

7. In connection with contentions of women artists groups that what they want is equal attention, not special treatment, they have sent out a questionnaire to museums requesting information on selection processes for exhibitions—how many curators go to how many studios, what proportion of women artists are looked at, etc.

8. Figures of male-female breakdown in Whitney annuals back to 1965 are as follows: 1969 (painting): 143 to 8. 1968 (sculpture): 137 to 10. 1967 (painting): 165 to 16. 1966 (sculpture): 146 to 12. 1965 (painting): 138 to 14. Since the pioneer protests of 1970, subsequent annuals, and the biennial of 1973, show a gradual—albeit very small—increase in the representation of women artists.

Dorothea Rockburne: *Sign*, 1970, chipboard, graphite, paper, oil (size variable). Bykert Gallery, New York.

Nancy Graves: *Shaman,* 1970, wax, latex, gauze, steel, oil paint, 12 feet high.

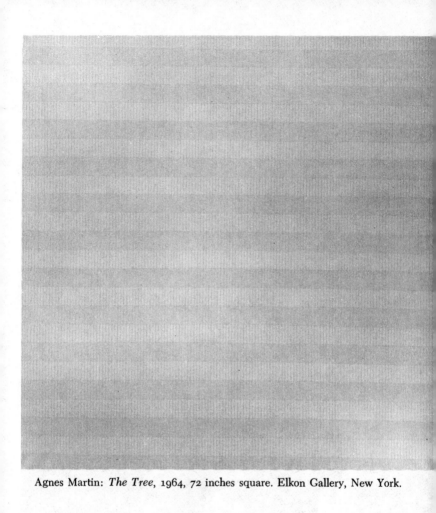

Agnes Martin: *The Tree*, 1964, 72 inches square. Elkon Gallery, New York.

One of the last works of the late Eva Hesse: *Contingent,* 1969, fiberglass and rubberized cheesecloth; 8 units, each about 14 feet high. Fourcade-Droll Inc., New York.

Lee Bontecou: Untitled metal and canvas sculpture, 1961, 6 feet high.
Castelli Gallery, New York.

Jo Baer: *Untitled (wrap-around painting)*, 1970, 48 inches high.
Goldowsky Gallery, New York.

Niki de St. Phalle: *Les Nanas*, 1966.

Kiki Kogelnik: *Liquid Injection Thrust*, 1967. 54 inches high.

Deborah Remington: *Balaton*, 1965, 74½ inches high.

Joan Snyder: *First Anniversary*, 1971, acrylic, varnish, and lacquer, 72 inches high.

IN THE UNIVERSITY

By
Lee Hall

Lee Hall is a painter, has had several one-woman exhibitions in New York, and is Chairman of the Art Department at Drew University, Madison, New Jersey.

As a woman artist in the academic world, I profess values and hold assumptions which, by their nature, make my arguments biased. I suspect, however, that my biases are no greater than those held by other persons speaking from any other well-defined points in social structure. I hope my biases are toward both truthfulness and fairness; I hope, too, that they do not poison my humor or patience or sense of balance. Let it be clear from the onset of this discussion that I am not interested in vendettas, quota-systems for hiring or firing or granting tenure on university faculties, supercharged rhetoric as an art form itself, or in bringing about the demise of institutions of higher learning. Rather, I am interested in promoting within universities and colleges an open and liberal approach to structure and governance, a blindness to sex or color or religious persuasion, and, most important, an atmosphere in which art can be explored and taught and learned. I believe it appropriate to expect no less from universities.

Fortunately, I am a member of an academic community where I enjoy (not suffer) the privileges (not rights) of rank and tenure. While I never think I have enough time for my own work, in fact I am able to go about painting on

a fairly regular and intense basis. I am paid well enough to stay a bit ahead of my debtors, to travel, and to give modest support to causes or projects which seem important to me.

Moreover, as an artist in an academic community, I have the opportunity to rub ideas daily against the ideas of colleagues and students. Despite the burdens of adminis-trivia and the irritations of committee work, I teach courses in subjects I value. At least a certain amount of my time can be given honorably to the preparation of material for those classes, for thinking about interesting problems, for looking at paintings or sculpture that I find compelling. In short, I am able to earn my living doing something I like very much to do. Be it bias or faith, I believe my lot in life a good one, a pattern that might be equally engaging and stimulating for other artists.

Before discussion can be focused sharply on the particular complex of problems attendant upon *women artists* in the academic world, more general comments are required about artists in the academic world and women in the academic world. Each group has problems as a result of the traditional roles and limitations placed upon it by the academic world. Neither group has won full membership in the academic world but, initially, I am interested in what universities should be vis-à-vis artists and women.

Interestingly enough, a male scientist, Robert Oppenheimer, described the utopian but conceivable relationship that might exist between artist and university. He wrote:

> I will turn to the schools and, as their end and as their center, the universities. For the problem of the scientist is in this respect not different from that of the artist or of the historian. He needs to be part of the community, and the community can only with loss and peril be without him. Thus it is with a sense of interest

and hope that we see a growing recognition that the
creative artist is a proper charge on the university, and
the university a proper home for him; that a composer
or a poet or a playwright or a painter needs the tolera-
tion, understanding, the rather local and parochial
patronage that a university can give; and that this will
protect him from the tyranny of man's communication
and professional promotion.[1]

From Oppenheimer's point of view, the artist would clearly
gain from an association with the university. It is also his
opinion that the university would profit measurably from
the association:

For here there is an honest chance that beauty will
take root in the community, and that some intimacy
and some human bonds can mark his relations with
his patrons. For a university rightly and inherently is
the place where the individual man can form new
syntheses, where the accidents of friendship and asso-
ciation can open a man's eyes to a part of science or
art which he had not known before, where parts of
human life, remote and perhaps superficially incom-
patible, can find in men their harmony and their
synthesis.[2]

In the years since World War II, many American uni-
versities and colleges have recognized the potentially dy-
namic and mutually beneficial relationship possible be-
tween artist and university. More than a few significant
artists have contracted the patronage of universities and,
with it, the responsibilities to institutional purposes, to
academic and curricular structure, to demanding schedules,
to dreary routine. Universities have been more or less will-
ing to forgive, occasionally even to be joyous about, the
apparent dichotomy between artistic or creative methods
of working and the more conventional methods of labora-

tory or lectern. On many campuses, there is genial coexistence between artists and persons engaged in other forms of pursuing knowledge or ideas.

Indeed, the marriage between artist and university has been so widely celebrated that it is surprising to find a major American institution of higher education owning up to Swarthmore's attitude:

> In the past two decades there have been fundamental changes in the position of the non-verbal arts at Swarthmore. The departments of Fine Arts and Music have grown, and offer majors in courses and in honors. Extra-curricular artistic activity has also been increasing, and the College has encouraged such activity by appointing part-time teachers in painting and pottery, by placing the orchestra and chorus under professional directors in the Music Department, and by providing improved studio facilities. *The college has thus tacitly conceded a place for creative arts in the academic community* [3] [italics mine].

The term *conceded* is not whitewashed by what follows:

> At the same time, the College has continued its policy of excluding the creative arts from the curriculum and from academic credit. This policy is based on the principle that intellectual and non-intellectual activities can be distinguished, and that the proper role of the College is to instruct in, and give credit for, intellectual activity.[4]

The conviction that art is a nonintellectual activity and, therefore, unsuitable for full membership in the college curriculum is slow to die. Art history, not studio art, is the accepted study. In a recent collection of opinion and observation, *The Arts on Campus*, one of the editors, Margaret Mahoney, summarized the situation:

In colleges in the northeastern part of the United States, art history has tended to receive more emphasis than studio work. The first program treating art history as a serious study began a little over 70 years ago at Harvard, under Charles Eliot Norton. Similar programs were established soon at Princeton, Yale, Columbia and New York Universities, each of these developing strong art history programs at both the undergraduate and graduate levels. Of the five, only Yale has a studio program that is equivalent in faculty and general acceptance to the art history studies program.[5]

Continuing, Miss Mahoney points out that it has become traditional for history of art and studio courses to be developed as separate departments and that "the studio program at a typical college is a series of progressively more difficult courses, most of which are open to any students who have taken the beginning course." [6]

While artists have joined the ranks of faculties in many universities, have contributed to the intellectual (yes, Swarthmore) life of campuses, there is no rule as yet to guarantee an artist's place on the faculty. It may be unthinkable to exclude a biologist or a classicist or, even, an art historian from a faculty, but artists are included too frequently only as a concession or as a benevolent gesture shaped by the niceties of public relations.

The results are interesting. First, college jobs are limited for artists; competition for such jobs is keen if not clean. Second, artists need never be subjected to apathy born of security on a university campus; the very nature of their relationship with a university is provisional and probationary.

At an earlier time in the history of education in America, administrators found artists unfit for participation in academic life because they had not earned advanced degrees or, bluntly, had not acquired the signs of membership and

achievement in the academic establishment. This is no longer the case. Without arguing the intricacies of how an artist should be educated, I call attention to how many are being educated: in increasing numbers, artists graduate from universities having majored in art and having met the other requirements for graduation operative in their particular institutions.

The College Art Association of America suggests the M.F.A. degree as the terminal academic degree for an artist-teacher. Some universities, however, do not recognize the M.F.A. as either a substitute for or an equivalent of the Ph.D. degree.

The artist's situation may vary from university to university. Some universities would be hell for any intelligent, sane, human being professing any fairly demanding subject at all. Such is the current cohesion and unanimity found in educational process and principle on American campuses. But artists are still only visitors on campuses, still suspected of nonverbal (and, therefore, unintellectual) enterprises, and still vexing in their lack of conformist (personnel policies use terms such as *usual* or *standard*) credentials for academic life.

All of which is to say that any artist may find himself or herself impaled on thorns among the ivy leaves. But the uncertainty with which universities harbor the artist indicates deeper uncertainties that arise apparently from a conflict between the traditional values of the university and recent pressures for reform in education. Unfortunately, the values which are assumed to have shaped universities in the past, those still extolled in commencement rhetoric and in the prose of the *Journal of the American Association of University Professors*, are values which now tend to fire furnaces which produce limitless heated discussions surrounded by hot air. Almost to a person, professors will at-

test that freedom, liberal thinking, tolerance for individualism, and the other virtues associated with academic institutions may or may not be woven into the fabric or life style of a particular campus. More to the point, policies of governance and administrative structures may impede or suppress the expression of such values as easily as they may assure their exploration and expression.

But artists are not the only persons who suffer in the abyss between academic values and academic practices, an abyss that is less charitably identified as hypocrisy, I suppose.

Consider women in the academic world. Women, like artists, have special problems in gaining equality on faculties, in winning rank and tenure, in acquiring university jobs compatible with their experience and education. It is true that women are on most faculties. It is true also that there are many more men on most faculties.

This is not a preface for a demand or even a suggestion that people should be hired on any basis other than competence or, better, excellence. It is, however, an observation which stimulates certain pertinent questions: Why aren't there more women on faculties when the sexes are nearly equal in national population? Are women less well educated? If there are fewer women prepared for positions in higher education, why? Are women less clever than men, less motivated? Do women flunk out? Fail to complete advanced degrees? Do they elect not to compete? Do they have the same opportunities as men to succeed in the academic world both as students and as professors? Or, is there prejudice against women in academic institutions? Obviously, none of these questions has a simple or certain answer, but the question of prejudice is at issue.

I believe there is prejudice against women in the academic world. I offer some observations in support of my contention:

First: Not only are there more men than women on most faculties but, with few exceptions, men in the academic world are rewarded better. Men make higher salaries, have greater opportunity for advancement toward greater rewards, and are more likely to acquire sufficient political power on a given campus to have some say in shaping policies and priorities which, in turn, determine the flavor of campus life.

Second: Merely counting women on a faculty is the grossest measure of prejudice. It is not sufficient to assume that a university is overwhelmingly socially aware and liberal if twenty-five to thirty percent of its faculty is female. A more careful examination of the structure for governance of a particular university is required if one is to understand the role and function of women in academic life. For example, there are likely to be more women at the ranks of instructor or assistant professor than at the ranks of associate professor and professor. Since promotion from assistant professor to associate professor generally signifies tenure (or job security), this is pertinent. Consequently, prejudice is evidenced on most campuses in the configuration of rank: women tend to be clustered in the lower ranks.

Third: Governing procedures in universities indicate prejudice against women. I believe it is significant to remark that relatively few women chair departments or participate in central administration, i.e., few women are deans or presidents of universities. Further, many committees which participate in governing a university are composed of tenured members of a faculty or those persons holding certain ranks, and women, because they are more likely to be untenured and to hold lower ranks, are less likely to be on such committees.

Opportunities for earning, advancing, and governing within higher education seem to be greater for men than

for women. Assuming that prejudice against women does exist—that the apparent advantages men have in the academic world are not illusionary—how does one seek out and examine the origins of the prejudice? There must be reasons, or at least rationalizations, that—real or not—cause department chairmen and deans to hesitate in hiring women. I have tried to analyze and distill from campus discussions some of the *reasons* men are preferred.

Evidently, women have earned a bad mark on the basis of emotional instability. They weep easily, I am told, and get frightfully upset when things go awry. My observations do not confirm what I am told. True, emotions run unbecomingly high and hot among the rational and considered types who populate a college campus, but I have seen as many angry men and women, irrational men and women, nasty men and women, petulant men and women, mean men and women. Without drawing up a catalogue of character flaws, let me suggest that both men and women can behave badly, can lose tempers, can make fools and public nuisances of themselves, and can raise stupendous hell on a whim. I daresay men and women may have learned (or been conditioned) to express their emotions differently but, when all the wounds are inflicted and the forked tongues tied, who cares? I mean, who besides the campus gossip really cares whether bitchiness originates in the male or female psyche?

Another notion often discussed is that women on faculties should not be trusted with demanding chores because they are not willing to invest in those chores the energies, hours, and dedication that men might. Men, it is argued, have more at stake in their careers, are more aggressive and more motivated. Observation fails me at this point. Productivity levels are difficult to measure on faculties. Even under the yoke of the dictum "publish or perish," productivity is elusive unless one is prepared merely to count

publications, giving each the same weight in terms of quality. For the sake of discussion, however, assume that any member of a university faculty should teach, should engage in his own discipline and offer evidence (publications, exhibitions, lectures, papers, seminars, etc.) of achievement, and should contribute to the daily functioning of the university through committee work, necessary record keeping, and even less challenging and less entertaining trifles. No one can quantify such evidences of productivity but, under normal university circumstances, one's colleagues have a good idea of one's value to the academic community. Energy and enthusiasm, attention to detail, and seriousness about meeting the demands of a particular job seem to me not to be sex-linked characteristics.

I confess that I have witnessed women employing the accoutrements of their stereotypical role in approaching and solving academic problems. That is, I have seen women engage in campus politics behind, as it were, the skirts of a man. I have also seen women who hesitated to muscle in on the presumed male domain of decision making, policy shaping, and governance.

Another claim that is made against women is that they are absent from class and neglectful of departmental responsibilities with more frequency than men. Admittedly, I have known some women who took job commitments less seriously than those to husband, children, car, and house. But, surely, not all female faculty members are irresponsible and not all look on their jobs as peripheral and therefore half-hearted undertakings.

Finally, I suppose individuals accept or define their roles in society. To the degree that women exercise individuality in this manner, I see no cause for prejudice against hiring them or promoting them or engaging their energies in governance within an academic institution. To the degree that an individual woman is defined by society, en-

gages in the stereotyped role that compels her to passivity and devaluation of her work, she is a liability to an academic community. She would be a liability to most other communities too. But, more important, a man conditioned to a similar fashion of life would fail also to contribute a great deal to his academic institution.

Thus, I think that we can say that artists and women, as separate categories, have won only provisional acceptance on university faculties. I think artists dwell within a matrix of prejudice directed at the very nature of the work they do; women, by the same token, encounter prejudice that seems to be compounded of old wives' (or old husbands') tales and various social expectations.

At this point it may be redundant to focus attention on *women artists* in the university, to combine two constituencies already ill-at-ease in the academic world. To engage in a discussion of women artists in the academic world is to review paradoxes and ironies that characterize aspects of the worlds of art, universities, and colleges, and the women's liberation movement. Not one of these categories is simple in itself, and not one is divorced from other forces shaping contemporary life; indeed, not one is divorced from a long and tortuously complicated history of clashing personalities, political permutations, and shoddily assumed, shakily constructed rhetorical ramparts. The subject, in short, is instinct with shadows and conflict.

I assume that universities are appropriate patrons of art, suitable communities to benefit from the presence of artists, and institutions responsible in measure for the education of young artists. I assume also that universities might employ artists using the same criteria as for men artists, that they might provide suitable education for young women and young men desiring to be artists. Therefore, I think it revealing to consider some of the problems that confront women undergraduates in art, women graduate students in

art, and women artists on university and college faculties.

In general, the problems that defeat women or embitter them in the academic world are seldom either dramatic or traumatic. More often, dailiness and ordinariness and predictable repetition of behavior patterns conspire to remind undergraduate and graduate women art students, as well as women artists on faculties, that they have somehow betrayed their social role, that they have become the pawns of their own unhealthy motivations, and that they have abandoned emotional stability for unfeminine ego-tripping.

Daily, ordinary, dependable, expected vexations, irritations, and put-downs are the forces that grain by grain erode confidence, purpose, and self-identity of women in the university art world. Consider, by way of clarification, some of the ordinary, expected, completely unshocking paradoxes that might be statistically defined:

First, Women art majors tend to outnumber men art majors in undergraduate departments, but there are more men than women in graduate art programs.

Second: A woman and a man may apply to the same graduate school, present almost identical evidences of achievement (portfolios, recommendations, grades) but the woman is more likely to be rejected and the man accepted.

Third: Women who are accepted into graduate programs in art appear to have less possibility for receiving financial aid. This, of course, is not exclusively an art-department pattern.

All college art teachers, men and women, have had to console a bright young woman art student with the ordinary, routine, banal explanation that graduate schools seem to prefer men. Disappointment and anger are routine experiences: I have watched women undergraduates discover that beneath the academic dove there is an ironic fist, that the gender-rating gulf wears sheepskin clothing.

Several examples reveal clearly the ambience that sur-

rounds undergraduate women art majors. Young women who would be artists encounter, straightaway, the attitudes of their parents regarding women as artists and art as a womanistic (pejorative term) caprice. One parental attitude syllogizes thus: daughter is an art major, art is impractical, thank god daughter is a girl without the probable responsibilities of husbanding resources in the suburbs. Another parental reaction to a daughter's decision to major in art is to demand that daughter prepare to teach in the public schools. Such a demand, of course, is for the daughter's own good because she is too young to realize that art is a suitable hobby but not a suitable vocation for a young woman.

A third common parental reflex is the assumption that something is wrong—usually morally—with their daughter. Surely she came to her wild determination only through the sinister influences of drugs, sex, communism, or rebellion against her family after all they did for her.

Some young women, however, have families who bless them and encourage them to make of their lives what they can and what they will. These students turn confidently to academic advisers in art departments for assistance in shaping curriculum and meeting the requirements of the college for a major in art. Academic advisers, like parents, can reflexively throw cold water, make wet blankets into shrouds, and pull the rug out from under a student who thought she was standing on neutral ground, if not home territory.

Just as young women intent on becoming artists encounter revelations of parental attitude, they may elicit from an art professor additional ordinary, routine signals of cynicism. Any one of the following ordinary remarks carries destruction: (1) You might as well major in art; you'll get a husband to support you anyway. (2)

Art is a good major for a girl. (3) Don't think majoring in art is one big hippy picnic.

I believe advisers counsel women more frequently than men to augment their studies in art with typewriting, home economics, merchandising, or courses in elementary education. By injecting these notes of either practicality or cynicism (choose your term), advisers in effect signal doubts about the seriousness, ability, and integrity of the student. In this key, and far more damaging, they may advise young women who want to be artists to give less than their best energy, less than their total attention, and less than their keenest sense of adventure to the development of their creative capabilities.

Fortunately, most of my colleagues seem neither unusually rude nor imperiously insensitive. I have found most art professors to be slightly to very interested in talking with art students; those who cast doubts or dilute confidence or put down high hopes do so out of unthinking, ordinary rudeness and routine insensitivity. To be more exact, when responding to a yong woman's interest in being an artist, art professors, like parents, may indicate reflexively that women are expected to be neither serious nor taken seriously in art.

An undergraduate woman pursuing an art major probably will not suffer the trauma of rapid-freeze rejection; rather, she will probably learn to live with the chilly presence of prejudice. Depending on her psychic persuasion, she will give up or she will fight back.

If she fights back, her energies may produce particularly bright heat, may even dispel the chill of cold water and wet blankets. She may be advised then to seek admittance to a graduate school and, perhaps, earn an M.F.A. and become a woman-artist-teacher.

And how do women fare in graduate art programs? The

first obstacle, of course, is admission to graduate school. But, let us assume that admission has been earned and financial problems solved.

The majority of graduate students will be male and, certainly, the majority of graduate professors will be male. The female graduate student frequently has the impression that she is trapped in an all-male university club.

Logically, no one would go to graduate school without strong motivation and a sense of purpose. Women, after all, are not even draft fodder, so their motivations toward graduate school should be above question. Logic has no more power in the graduate milieu, however, than it has in undergraduate schools. Prejudice, not logic, is at issue.

Again, a female graduate student usually has to overcome more obstacles than a male graduate student in art. She will be asked what a nice or attractive girl is doing in graduate school anyway. She will be asked if her real purpose in graduate school is husband-catching. She will be asked, perhaps obliquely, if she wants to be an artist, or if she really has some sort of hang-up about artists. Eventually, too, someone will wonder why it is that she wants to compete with men.

Again, the woman art student can give up or she can fight back. She may win or lose. No one cares about losers, but then, winners become losers if they have to learn to be also-rans. That, in effect, is what seems to happen to most women artists who become college or university teachers. Nonetheless, some women artists do seek and find university teaching posts, but rarely do they live happily ever after in the security and community of an academic institution.

Women artists in university departments of art, I submit, are more likely to be teaching introductory courses in design and drawing than advanced professional courses in

painting and sculpture. Women artists are less likely to be appointed artists-in-residence than are men. In general, women artists on faculties seem to get the bad ends of two sticks at once: they are cursed as women and as artists.

Since World War II, some of the most interesting artists in America have been women. It has been suggested in some quarters that women artists exist despite the best efforts of dealers, curators, and the public. Be that as it may, women artists are an authentic part of American contemporary art, not because they are women but because they are artists. There would be less to look at and less to talk about if we saw nothing by Louise Nevelson, Jan Gelb, Jean Linder, Lee Krasner, Ruth Vollmer, Helen Frankenthaler, Lee Bontecou, Nell Blaine, Grace Hartigan, Joan Mitchell, Alice Baber, I. Rice Pereira, Georgia O'Keeffe, Loren MacIver, Marisol, Anne Ryan, or Eva Hesse.

If women artists were less good as artists, or if there were fewer women artists, I could see a reason for their being few women on art faculties. As it is, there are excellent women artists and they exist in far greater proportion than their number on university faculties suggests. One cannot adequately account for the phenomenon by pointing to the compounding of the difficulties of women and artists in the academic world. As Elaine de Kooning writes elsewhere in this volume:

> To be put in any category not defined by one's work is to be falsified. We're artists who happen to be women or men among other things we happen to be . . .

After all, as a human being, one might also be an artist, a woman, a man, a university professor, or any number of other partial identities. As human beings, we might agree

that wars based on sexual, racial, and even political conflicts are, finally, civil wars: to attack any part of humanity is to attack a part of oneself. Fairness, justice, openness, tolerance, and celebration of individuality are no less desirable because they are difficult to effect or because they are so seldom employed. *O tempora! O mores!* May we all eschew falsification that issues from categorization.

NOTES

1. Robert Oppenheimer, *The Open Mind* (New York: Simon and Schuster, 1955).

2. *Ibid.*

3. Swarthmore College, *Critique of a College* (Swarthmore: Swarthmore College, 1967).

4. *Ibid.*

5. Margaret Mahoney, ed., *The Arts on Campus* (Greenwich, Connecticut: New York Graphic Society, 1970).

6. *Ibid.*

Lee Hall: *Formation and Cadence,* 1969, 52 inches high.

Barbro Ostlihn: *Erik's House*, 1965, 89 inches high.

Cecile Abish: *Loosely Extended Red Field with Flat End*, 1970, vinyl, stiff and soft foams.

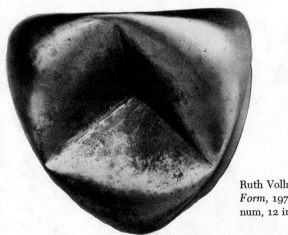

Ruth Vollmer: *Steiner Form,* 1970, cast aluminum, 12 inches high.

Miriam Schapiro:
Phoenix Flower, 1971,
72 inches high.

Mary Bauermeister: *No More Stones,* 1964, stone drawing, 24 inches square.